IMPACT OF AMERICA

DANTÉ CHARLES

Copyright © 2022 Danté Charles
All rights reserved
First Edition

NEWMAN SPRINGS PUBLISHING
320 Broad Street
Red Bank, NJ 07701

First originally published by Newman Springs Publishing 2022

ISBN 978-1-63881-188-6 (Paperback)
ISBN 978-1-63881-189-3 (Digital)

Printed in the United States of America

To all people who hunger for knowledge by destroying ignorance and embracing wisdom. Don't go through life thinking only what you have been fed to believe. Find out how life-changing and rewarding it is to utilize your own mind. This is dedicated to you.

Introduction

The views in this book do not reflect my personal feelings about any group of people. My support and association consists of a diverse circle of individuals within my family and outside of my family. Truth deals with a lot of uncomfortable details, which are all a part of real American history. The book is 90 percent research-based factual information. Around 10 percent of my opinions and views are solely based on the negative impact America has had on black and brown people. My views address the behaviors and mindset of those toxic individuals no matter the race or nationality.

The personal views also highlight the fact that I despise ignorance and believe that the only way to combat ignorance among all human beings is to face it directly with uncut uncensored educational content. If the ignorance is uncut and uncensored in damaging the mindset and lives of a group of people, then speaking on that ignorance must be uncut and uncensored to understand the severity of a damaging impact ignorance has on people. The word *ignorant* sounds negative and degrading because we have made it to sound that way. However, ignorance simply means one doesn't know.

Ignorance is simply not having knowledge or any understanding of what a topic or issue is about, not being educated in the subject of what's being discussed or what a nation of people is suffering through or experiencing. Ignorance blinds you from even knowing that you are ignorant. An ignorant person usually doesn't have a clue that they are ignorant. Usually because one has no idea of how ignorant they are, they fail to seek knowledge or even accept knowledge when it is offered to them. Ignorance cripples you from being able to tell the difference between substance-based information and more

misinformed rhetoric. It is my heartfelt wish and purpose to share more solid accurate information and help destroy ignorance and its impact that has lasted for hundreds of years.

We must all destroy ignorance and impart wisdom and knowledge. This is a part of the healing from the impact of America.

The additional purpose of this book is to refresh the resources of true American history. This is a guide to motivate those who are hungry for truth to research beyond this book to find consistency in the occurrences and the impact America has made on all of us. I do not believe in speaking on the problems or the troubles without offering solutions. Therefore, I can tell you right now that the solution to much of what is shared in this book is simply releasing yourself from a conditioned mind and learning to use the powerful tool God gifted to every one of us—the brain.

Our brain is a tool that can be most effective if we learn to use it and not allow other people to use it by pouring their own ideals and doctrines into our brain. Break free from shackled minds and see clearly all that is in front of you and all that God intended for you to see. You cannot be manipulated or conditioned if you stay educated and aware. Be open to hear other views and accept when something makes perfect sense whether the information came from someone you like or dislike. Truth is universal, and when it is told or heard, it should sound the same and be filled with the same details. Understanding the difference between truth and myths and realizing that truth won't always feel as good or comfortable as fairy tales. Accept when you are wrong and do not be afraid to explore something you've never known or heard before. Studying and comparing information and not run when you discover that what you may have always believed may not have been all truth. Be a part of the solution and not the problem. All of this is a solution to the impact of America.

"In the Beginning": The Bible

In the beginning, America and much of the world were taught to believe that man came first, that a woman was created from his rib, and that from the books of Genesis through Revelations of the Bible women were written as the downfall of all men from a psychological standpoint, physically, emotionally, and spiritually through subliminal content. In the meantime, various versions of the Bible were created and rewritten, and we were all trained and conditioned to believe what was taught to us. Eight hundred scrolls of the holy book were taken and hidden 200 years After Christ (AC), and no one to this day has challenged or investigated thoroughly why this entire book went away and, most importantly, what the contents of this entire book possessed. Some portions of the missing scrolls have always been reported to be held in the secured areas of the Vatican in Rome, Italy.

Contrary to what America taught us through multiple generations, thousands of years later, we discovered in the new world that DNA proves without question that all humankind originated from an African woman. This came from a current era of science and education and more conscious-minded people who are inquisitive and passionate about knowing truth versus myths. You will find that truth is universal and people of arts and humanities, scientists, anthropologists, and historians all agree on the same factual premises that have all been proven through DNA just as gravity, gas, matter, and wind, have been proven through a lifetime of experiments.

What America discovered early on prior to slavery was that a system through religion had to be designed in order to operate a method that would help build a country with one vision and one

goal in mind. That vision was to create a world that would uplift and benefit the European's ideals and plans to take control of land, keep control of land, and become the power of every area they came in contact with. This system through religion had to be a powerful method that would have a stronghold on the minds and hearts of mankind.

They understood that having power over the physical being of man was not important because if they could control the mind and emotions, then they would have full control of the whole individual.

An idea or belief lasts forever. Human beings die off, and oftentimes, their works and accomplishments die with them. But if an idea is given life and taught to breed through generations of people, that idea or belief will last for a lifetime.

The most powerful concept known to man to this very day was the introduction of the system of beliefs through religion. Religion was created almost 5,300 years ago and was originally interpreted as mythology related to ideas and beliefs. This was when the study of religious beliefs began prior to writings and record-keeping materialized about beliefs. Through the belief system, the concept has been used all over the world to guide human beings to conduct themselves in the manner of what they believe. This dictates behaviors relating to family, sex, relationships, gender roles, business, dieting, health, and other personal life situations. The belief system is what makes every human being think and feel what they do and directs their decisions and choices that impact their lives and others' lives.

The impact from the belief system is not that beliefs are a bad thing. The problem has always been that the beliefs are not all aligned with truth and not completely designed to benefit the individual, but rather designed to benefit the system that we all live in. However, because of there being multiple characteristics and personalities in the world, it is very important to have beliefs because it helps to control irrational thinking and impulsive behavior. Consider the fact that we have numerous heinous crimes and behaviors in the world with beliefs. Imagine how dangerous society would be if there was no belief system. Therefore, it should not be misunderstood that beliefs are bad, but rather the way belief systems have been used against us

as human beings and the purpose behind the beliefs will always be questionable.

Another important truth about beliefs and the system of beliefs is that beliefs are and have always been very personal and have a completely different meaning from truth. Truth and beliefs are two totally different things. What one believes is what that person truly feels to be true or hopes to be truth based on how passionate they feel about what they have been taught to believe. However, truth is not as complicated. Truth is what it is and remains what it is from the beginning of time until the end of the world. Truth needs no help from man and doesn't have to be dressed up or made to comfort anyone. Truth is truth no matter whether it hurts or brings discomfort. Truth stands alone and does not care how anyone feels or thinks about what it is. For example, brick walls are made of clay and shale. Driveways are made of cement. No matter how much you debate those truths, there is nothing that can be done to stop this from being true. Those are the only minerals that will create bricks and driveways. Gravity pulls toward the earth. This is something we have seen all of our lives each and every day we live and function. Gravity is real and true. If I were to tell you that I believe in my heart that man went to the moon, then that would have to be thoroughly investigated to see if it was even possible for humankind to even make it to the moon. This could be a long debate because it is not something that is solid simple truth. Some Arab men believe in their hearts that if they kill or commit suicide in the name of Allah, they will receive ten virgin wives when they die and go to heaven. This is their belief, and as crazy as it may sound to some, it is very real to them.

If we are taught to believe something from infancy to throughout our entire lives, then how could any of us allow anyone to break us from what we have been taught to believe since in our mother's womb? This is why we often die believing what we are taught no matter if there is no truth to it or not. My point is, we are conditioned to get caught up in beliefs than in truths because beliefs feel so much better and cover/hide reality that we are not able to handle because we have been conditioned to live off lies and fairy tales. Beliefs and emotions are best friends when it comes to the conditioning of a

people. Truth forces us to face uncomfortable realities that we are not able or ready to face. Many of us feel better even dying with only our beliefs and never having known or dared to face the truths beyond our beliefs. "We hold stronger to our beliefs than to the realities that we live in" (Dante R. Charles).

Beliefs are personal and sentimental, which have absolutely nothing to do with truth. What you believe is what you feel or understand to be true because someone taught you your beliefs and raised you to believe certain things. If your beliefs are all you know and have ever been taught, then you fight and push against anything else that is presented to you as the real truth. Also by holding fast to beliefs, you weaken your mind to explore the possibility of there being something beyond what you have been taught to believe. You become conditioned to follow and absorb anything fed to you rather than having a mind of inquisitiveness to want to know more. Strong beliefs make you dare to question what doesn't make sense and block you from having an open mind to research the answers to what you may not understand about your beliefs. To accept what someone says to you without researching outside of what is taught to you is the same as allowing yourself to remain blind when the cure to your blindness is sitting on the table right in front of you. But because man or an organization told you that you cannot see because it was destined for you to be blind, your trained mind accepts that, and you walk away from the table that holds the antidote that will cure your blindness instantly. So we die with these beliefs, never exposing ourselves to the truth because we feel so confident and secure in trusting what has been taught to us instead of knowing for ourselves. If God is not the master or maker of confusion, then what makes us think that all of our beliefs joined by numerous cultures, religions, and denominations have any relativeness to truth? We fight against other beliefs and shout what we believe is the answer when numerous other religions feel the exact same way.

> Infiltrate the minds of a people with foreign ideals and agendas that have nothing at all to do with the elevation of that people, results in

> a divided people and destruction of an entire nation of people. This impacts a people for hundreds of generations. After the invasion of our minds through conditioning, abuse, traumatic slave processes that never stopped working, politics, flawed religion and manipulation, the self-destruction works all on its own like a virus or disease out of control with no access to the cure. This explains what has happened to Black people in America. Some can see it, some never will and often take the rooted confusion to their grave. (Dante R. Charles)

Some factors to consider about the Black community and our beliefs. It is important that the reader understands that I too am a believer and I know there is God. However, I don't allow religion to cloud my thinking or the wisdom God gave me. There are churches on every corner of America—not only in the black neighborhoods but also everywhere. From childhood, black America has been taught to focus and give more time and money to the church. We as black people give more tithes and offerings than we give to strengthen our financial stability or community. So we fill the church's pockets with millions of dollars, yet we still don't own much of America. However, white Americans pour more of their money back into the colleges and universities as alumni all over the country and invest time and money into financial stability, organizations, and business and continue to prosper and stay on top even while being the true minority this current day in America. None of this means blacks have not excelled and progressed, because we have done extremely well as we always have done. However, as a whole people, we continue to fight the same struggle from years ago because we are still shackled through conditioning of the mind—conditioned to put all of our focus and effort on paying tithes and keeping our money to ourselves for our own selfish ideas and goals rather than building our economy together as a whole. As a result of us only being trained to pay our churches, our colleges do not excel as well as they really could.

If we put half the money back into our colleges as we do in tithe and offerings, we could have an empire of strong, stable institutions that carry us far beyond graduating and into our own industries and opportunities linked to our colleges. This does not mean stop tithing to your church. It means use that same stronghold of mindset to invest back into your own community. Black Wall Street accomplished this mindset and financial building with far less blacks than we have today. And today we have far more wealthy blacks and upper middle-class families who can make an even bigger economic impact today than Black Wall Street made years prior.

Have you ever wondered why it is so easy for churches or faith-based organizations to acquire money from the government under a nonprofit or faith-based category? Or even bank loans are a little easier to obtain if you are starting or building a church? It is because the church and the system of beliefs feed into the system of America and its way of controlling thoughts, behaviors, and generational mobility. It keeps the belief system alive and thriving, which leads to politics, voting, and the direction in the favor of powerful America. If the powers of America promote and fly a flag of godliness, then anyone within those beliefs will surely vote in favor of politicians and government that appear to represent godliness. Here is where the system is used as an unethical method of convincing believers to vote for particular candidates that pretend or appear to share the same beliefs. However, the persons running may not be anywhere near godliness nor have any knowledge about God at all. Yet conditioned minds will follow because that is all they know how to do—follow like the sheep.

So it is all a fully tried system that ties beliefs, religion, and government to keep a society operating in favor of the elite and powerful. One simple evidence to this truth is in every major city and state all over America; Asian, Latino, and Jewish communities have their own independent resources of food supply and banks. The reason they are able to build independent communities in this country the way they do is because they are not distracted or conditioned by the American teaching of faith and beliefs. Although they have their own beliefs, it is not from the American culture of beliefs. Therefore,

there is nothing shackling their minds that stops them from building for themselves and uplifting their own community to be financially independent.

Ask yourself, how often do you see an Asian shopping in Kroger, Walmart, Publix, or any traditional American grocery store/supermarket? How often do you see Latino shopping in the common grocery stores like Kroger or Publix, Food Depots, etc.? You don't see them there as much or not nearly by the numbers as you see blacks because in most Asian and Latino communities all over America, they have built their own areas to provide the same culture and foods of their country. And those dollars circulate right in that community where they live and operate over and over again before leaving their community.

The resulting impact that black Americans are left in as a direct result of our never having broken away from the system of America is we are in helpless bondage to America. America holds all the resources we must have in order to live and survive. We fought so hard to be accepted by America when America showed us throughout generations that they did not want us to be a part, but they only wanted to used us for the benefit of America. When we should have been working toward building our own communities with our own banks, grocery stores pharmacies and farming, we were distracted by church, staying in the Word and paying our money back into the system of America instead of paying into our own financial independence and stability.

We were distracted by trends such as clothing and jewelry, which kept us blindly operating within America's system and never building or owning anything of our own. We were taught to idolize the merchandise and materials but never taught to own or create the same merchandises we spend all our money on. During family gatherings, reunions, and fellowship, we would spend time debating over all the characters and stories in the Bible, while white Americans, Jewish Americans, and Asians would use the opportunity to discuss how to bring their money together and invest in the next productive idea to bring the family financial stability. Yes, we have accomplished a great deal, but as a people, we still rely on America to feed us, clothe

us, and care for us in ways we could be doing for ourselves by producing the exact same sources that are mass-produced by America. Many years we open our eyes and realize that everyone has a piece of America and thriving businesses that will pave the way for generations of their people except us. Nevertheless, we remain asleep with the Bible grasped tightly in our hands owning nothing as a people but promises.

Why Christianity and Christian Morale Are Imperative to the Survival of America

Despite the deceitful and manipulative way man has used Christianity against black and brown people, the positive life of Christian ideals impacts the spirit and mind in ways that must continue in America. The principles of Christian morale and inspirational and spiritual word of God give life and healing to wounded hearts, minds, and souls. Without this concept and idea, it would leave the masses of people lifeless spiritually, psychologically, and physically. The following are examples of areas of life wherein Christianity healed the broken and solemnly sustained the average human being:

- Emotional trauma.
- Reforming those who are incarcerated and changing the mindset to doing right from wrong and living a more productive quality of life.
- Individuals who are dying spiritually within, emotionally, mentally, and need inspirational and spiritual guidance and hope to persevere.
- Individuals who need deliverance from a life of risk and troubles (trials and tribulations).
- Substance abuse. Spiritual guidance and principles are keys in this healing. Constant studying and reverence over inspirational encouragement and Christian-based steps.

- Alcoholics. Spiritual guidance and principles are keys in this healing. Constant studying and reverence over inspirational encouragement and Christian-based steps.
- Organizational structure. Christian-based principles used as the culture of an organization yield positive fruit. Chick-fil-A is the most phenomenal example of how Christian-based customer service training and practices make them the leading fast-food chain in the world. Because of the Christian morale Chick-fil-A teaches to their employees, they represent the rewards of treating customers with decency and respect, and the customers leave with a feeling of having been respected and their money appreciated.
- Church. Pushing and promoting the principles of being decent to all mankind and treating others in the way you wish to be treated. Facilitating the Book of Life as a daily guide to all mankind, living and walking in love. Respecting the beliefs of others whose conclusion to their belief is in an almighty God and peace to all people.

Ultimately the true concept and purpose of Christianity would contribute to making the world a better place as long as man doesn't use it as a mask to hide racism, manipulation, and hatred behind the holy front. Man must stay out of trying to control the purpose of Christianity by making it a selfish weapon for his benefit while hurting those who believe wholeheartedly in the ideals.

The Disadvantage to Allowing Your Belief to Turn You Away from Others Who Have a Different Faith

Open your mind for just a moment and absorb this perspective. When we allow man to manipulate God's word, we fail every time and have no idea we have failed. When we allow man to make the poor attempt to interpret God's word by putting our personal indoctrinated ideals and feelings on the way God thinks, we fail every time and have no idea that we have failed. To make my point clear, let's look at an example. Why limit your chances on finding love by following a mandate that says your new love must follow the same religious denomination that you follow? How realistic does this become in a world that consists of a million characteristics and a million religious beliefs? What happens when the person you fall head over hills for happens to follow a different denomination from you? Keep in mind God's thoughts are not our thoughts, and he certainly does not think the way that we do. We have adapted to the imagination that we think the way God thinks and have forgotten that his mind is far beyond our small minds. Evenly yoked in God's way of thinking does not mean what we have been taught. Yes, it is wise to find a mate that shares those important things that both individuals should see eye to eye on; however we have taken the understanding of this completely away from understanding at all.

If you meet a lovely lady or pleasant man and both of you are overjoyed with what you find in each other, then this is a relationship worth exploring. If this person possesses everything you have

ever wanted, or even things you never realized you needed in your life until you met this person, then this is a relationship worthy of exploring. If this person leaves you with no complaints and even their flaws are beautiful in your sight, then this relationship is worthy of exploring. Now after meeting this wonderful person and discovering all the things about this person that would make you happy in a relationship or marriage, why on God's green earth would you disrupt this blessing by allowing the fact that this person is a bloodiest and you are a Christian stop what was transparently a beautiful union?

This will be hard for some of you to absorb if you don't think about this point with critical thinking. If an individual treats you better than you've ever been treated in a relationship, there are no material distractions, no alluring distractions motivated by society. There is only what the two individuals pour into each other's life through personality, respect, integrity, consideration, honor and genuine care. It would be committing emotional suicide to do this to yourself, and this is the pain we inflict on ourselves under the pressures of religious ideals, which have nothing to do with the true word of God.

The divorce rate in America was always alarming due to a number of reasons. Therefore, if the divorce rate of America has always been an issue in America, what makes us think that our traditional way of thinking is the solution to lifelong happiness? God did not promise us who would be our soul mate, where we would meet them, or what idea of God they would believe in. What happens is we fixate our minds on the imaginary description we have been taught to look for. We get in our own way of blessings that God has sent our way.

We block God's blessings every day because we put our little pea brains in the way of God trying to bless us. The only reason the divorce rate has gone down slightly in 2020 is because millennials are choosing to wait till they're older to get married, which has recently added to longer marriages. My advice to anyone single looking for love especially if you're forty-five or older is this—please don't prolong your lack of love and happiness by worrying about that man or woman being Muslim, Christian, bloodiest, Catholic, Protestant, African Methodist, or Methodist. I boldly stand to tell you that is and always have been foolish. Fall in love with someone who loves

you with the godliness and sincere treatment that you deserve. If you find someone with your same exact faith and beliefs, fine. But don't send yourself into old age alone because you're trying to uphold a tradition that doesn't benefit your happiness, but only a continued system of American ideals.

The other disadvantage is just the simple fact that there are so many beautiful people with godly beliefs. Christianity is not the only denomination with wonderful people. So we do a disservice to ourselves when we block relationships with other positive individuals who have different beliefs and ruin great friendships and possibilities of accomplishing powerful things by choosing not to interact with others who don't believe the exact same things we believe as it relates to our personal faith.

A Short List of Misleading Myths with No Foundation of Truth or Evidence of Proof yet Americans Buy into It like Blind Sheep

Myth. Any church that does not have the name God or Jesus in the name of their church will not make it into the gates of heaven and members will not see heaven. (Mere foolishness. I am so thankful that God does not think at all like we do.)

Myth. Half-read scriptures such as only 144,000 will make it into heaven.

Truth. The believers of this missed an entire continued scripture that stated, "Then John saw a number that no man could number."

Myth. Columbus discovered America.

Truth. The only thing Columbus discovered was the fact that the Native American was already there enjoying their land when he arrived.

Myth. American astronaut Neil Armstrong went to the moon.

Truth. There is no solid proof to this day, and I don't expect to ever see it being that it never happened. The calculations for distance, oxygen needed for a human being to make that journey, food, body pressure of traveling that deep into space, and making it back have never publically been discussed or challenged by astronomers or scientists. We have also not been back to the moon since we alleged to have gone. So why haven't we returned to commemorate the first historic trip? Why hasn't any other country all over the world ever

made the trip after we claimed to have been in the first place? Why have we only sent robots and machinery vehicles there within the years since Armstrong landed there? Just some things to think about.

Myth. Thomas Edison invented the electric light bulb.

Correction. Lewis Latimer was a black inventor and the son of former slaves. Lewis Latimer invented the technology inside of the light bulb that gave it longevity of light. Thomas Edison was given full credit for the light bulb. However, the light bulb did not work properly nor did it stay on until Lewis Latimer contributed his invention of technology for the light bulb to work.

Myth. The Thanksgiving story of Pilgrims and Indians having a nice feast together.

Correction. This had more to do with Pilgrims stealing land from Indians and manipulating and taking advantage of the Indians' kindness.

Myth. White Tarzan leading Africans around their own land and teaching them about the jungle and wild animals that Africans have lived and cohabitated around their entire lives. (Foolishness.)

Myth. The Bermuda Triangle and all the missing planes and ships that passed through that area. (No solid proof or findings to this day to confirm this old myth.)

Myth. George Washington chopped down the cherry tree and had wooden teeth. (Not even worth researching but was never confirmed as being real.)

Myth. "Jack of all trades, master of none."

Truth. This cliché was designed and promoted by a people who had only one talent. The envy and jealousy speaks against all those who are talented and skilled in multiple areas. It does not mean that just because you are talented in many different trades, you don't master any of them. That has always been straight foolishness. Why can't you have multiple talents and gifts and be damn good at all of them? One can be talented in multiple trades and actually master each talent. Again this is a mindset of insecurity and feeling inadequate because you don't possess more than one skill or talent. So the next time you hear someone make this negative cliché toward you or

anyone, ask them how many talents they have and to stop being mad at people who "master" more talents than they do.

Truth. Most fairy tales were not at all happy cheerful truths. Most fairy tales originated from gruesome real-life occurrences. For example, Hansel and Gretel's true story had to do with child abandonment and attempted cannibalism, murder, and child enslavement.

Myth. Africans sold other Africans into slavery.

Truth. This is inaccurate when you look at the actual occurrences during the onset of slavery and how the stage was set. There were always tribal families that lived in separate parts of the land. When Europeans invaded Africa, they brought gifts for trading similar to the method used in taking land from the Native American. Europeans offered guns to certain African tribes to cut down their hunting for food from weeks to a month down to one day. This along with other tools was used as barter by leading Europeans to abduct and kidnap other rival African tribes. Before this level of division was introduced to Africans, they knew nothing of this level of hate and betrayal toward one another. They respected their rival tribes and protected their boundaries from the other. It is important that as we tell the story, we must be accurate and explain the details of what actually took place. The point is that we knew nothing about selling other Africans until it was presented and taught to us.

Myth. Pres. Barack Obama did nothing for black people during his eight-year presidency.

Truth. Here are some little details of what Pres. Barack Obama accomplished for blacks while in office according to obamawhitehouse.archives.gov (for the slow folks, that means this is directly from the White House Archives, which record the works of every past and current president of the United States):

> The poverty rate for African Americans fell faster in 2015 than in any year since 1999. While the poverty rate fell for across all racial and ethnic groups this year, it fell 2.1 percentage points (p.p.) for African Americans, resulting in 700,000 fewer African Americans in poverty.

African American children also made large gains in 2015, with the poverty rate falling 4.2 percentage points and 400,000 fewer children in poverty.

Since the start of Affordable Care Act's first open enrollment period at the end of 2013, the uninsured rate among non-elderly African Americans has declined by more than half. Over that period, about 3 million uninsured nonelderly, African-American adults gained health coverage.

Since President Obama took office, over one million more black and Hispanic students enrolled in college.

Education:

The U.S. Department of Education (ED) is responsible for funding more than $4 billion for HBCUs each year.

Pell Grant funding for HBCU students increased significantly between 2007 and 2014, growing from $523 million to $824 million.

The President's FY 2017 budget request proposed a new, $30 million competitive grant program, called the HBCU and Minority Serving Institutions (MSIs) Innovation for Completion Fund, designed to support innovative and evidence-based, student-centered strategies and interventions to increase the number of low-income students completing degree programs at HBCUs and MSIs.

The First in the World (FITW) program provided unique opportunities for HBCUs to compete for grants focused on innovation to drive student success.

In 2014, Hampton University received a grant award of $3.5 million.

In FY 2015, three FITW awards were made to HBCUs, including Jackson State University ($2.9 million), Delaware State University ($2.6 million) and Spelman College ($2.7 million).

While Congress did not fund the program in fiscal year 2016, the President's 2017 budget request included $100 million for the First in the World program, with up to $30 million set aside for HBCUs and MSIs. (Obamawhitehouse.acrchives.gov)

During his last two years in office, Obama freed almost one thousand black men from prison who were serving overextended sentences for crimes that did not fit the punishment.

Criminal Justice

The incarceration rates for African-American men and women fell during each year of the Obama Administration and are at their lowest points in over two decades. The imprisonment rates for African-American men and women were at their lowest points since the early 1990s and late 1980s, respectively, of 2014, the latest year for which Bureau of Justice Statistics data are available.

My Brother's Keeper

President Obama launched the My Brother's Keeper initiative on February 27, 2014 to address persistent opportunity gaps faced by boys and young men of color and ensure that all young people can reach their full potential.

Nearly 250 communities in all 50 states, 19 Tribal Nations, Washington, DC and Puerto Rico have accepted the President's My Brother's Keeper Community Challenge to dedicate resources and execute their own strategic plans to ensure all young people can reach their full potential.

Inspired by the President's call to action, philanthropic and other private organizations have committed to provide more than $600 million in grants and in-kind resources and $1 billion in low-interest financing to expand opportunity for young people—more than tripling the initial private sector investment since 2014.

In May 2014, the MBK Task Force gave President Obama nearly 80 recommendations to address persistent opportunity gaps faced by young people, including boys and young men of color. Agencies have been working individually and collectively since to respond to recommendations with federal policy initiatives, grant programs, and guidance. Today, more than 80% of MBK Task Force Recommendations are complete or on track.

African-American Judicial Appointees

President Obama has made 62 lifetime appointments of African Americans to serve on the federal bench.

This includes 9 African-American circuit court judges.

It also includes the appointment of 53 African American district court judges—including 26 African-American women appointed to the federal court, which is more African-

American women appointed by any President in history.

In total, 19% of the President's confirmed judges have been African American, compared to 16% under President Bill Clinton and 7% under President George W. Bush.

Five states now have their first African-American circuit judge; 10 states now have their first African-American female lifetime-appointed federal judge; and 3 districts now have their first African-American district judge.

Also, the President appointed the first Haitian-American lifetime-appointed federal judge, the first Afro-Caribbean-born district judge, the first African-American female circuit judge in the Sixth Circuit, and the first African-American circuit judge on the First Circuit (who was also the first African-American female lifetime-appointed federal judge to serve anywhere in the First Circuit).

The President is committed to continuing to ensure diversity on the federal bench. This year, the President nominated Myra Selby of Indiana to the Seventh Circuit, Abdul Kallon of Alabama to the Eleventh Circuit, and Rebecca Haywood of Pennsylvania to the Third Circuit. If confirmed, each of these would be a judicial first—Myra Selby would be the first African-American circuit judge from Indiana, Abdul Kallon would be the first African-American circuit judge from Alabama, and Rebecca Haywood would be the first African-American woman on the Third Circuit In addition, two of the President's district court nominees—Stephanie Finely and Patricia Timmons-Goodson—would be the first African-American lifetime-appointed federal judges in

each of their respective districts, if confirmed. (Obamawhitehouse.archives.gov)

Needless to say, it is imperative that we stop adopting the Simon said mentality of repeating inaccurate foolishness from uninformed people. It is so easy to repeat the same lie and myth that we've heard other lost individuals say instead of researching unbiased truths for ourselves. When we take on a Simon said mentality, it gives birth to LAZY behavior and a LAZY mindset. Taking the words and ideals from someone else who knows nothing of what they are talking about and spreading ignorance all over a nation destroy us as a people. If I got a penny for every black and white American that repeated the lie of Obama not having done anything for blacks during his presidency, I would be a billionaire. Erase ignorance with truth and make it a lifelong habit.

Furthermore, the other amazing accomplishments President Obama accomplished for black people in America were right in front of our eyes daily. But only unconditioned eyes could clearly see it. The following are the contributions President Obama gave to black America, but most of black America was too distracted and blinded by self-hate, religion, Simon said mentality, and a great lack of political knowledge and understanding:

- Obama represented black men better than any other black male public figure of this era.
- What so many Christians completely missed about Obama was the fact that he exhibited exactly what he truly believed in by the life he lived. His life was an exact replica of a Christian who believed in family, reproduction of life and family, marriage, and the continued cycle in the way he and his wife raised their daughters. People missed that he lived his life according to his beliefs and ran the country according to the job description of leading a nation of diverse people and mindsets. He kept those two things separate as he should have. Some of you may never understand this and might be the reason why God led you down your path

and led Obama and others down their path. Your level of understanding would never lead you to leading a nation of people. You are positioned exactly where God wanted you so that you don't take on any responsibilities that might disrupt the operation or lives of the masses. Be happy for where God placed you, and understand that Obama's direction was nowhere near where God lead you.

- Obama's existence as president destroyed the lifelong stereo type of black men being lazy, being incompetent, with a long criminal history, or with a shady background. He came to the White House squeaky clean. Yes, that's right—I can boldly state without any fact-checking that President Barack Obama did indeed move into the White House squeaky clean with no scandal, no adultery, no previous bad business deals, no courting or soliciting sex from prostitutes or strippers, no tax evasion, and no corrupt political history. He completed two full terms and left the White House squeaky clean and still remains an upstanding black man, husband, and father. Now for some reason, a lot of black folks still don't like him. This is when you question the lives and insecurities of those who didn't like a man who only represented his people in the most outstanding way. This doesn't make me wonder about Obama. No, this makes me wonder about the people who hated him. What's going on or not going on in your life to not be able to recognize a noble man of substance and solidarity? Something's more wrong with you than him.
- Obama brought the culture of black people to the White House for the world to finally see the drastic difference from what America painted of black men over a hundreds of years.
- Obama lived and represented a Christian life better than 90 percent of the Christians who voted against him and disapproved of him.
- He modeled what a responsible black man and father is supposed to look like. He was present for his children

before, during, and after his presidency. He fathered his daughters with Christian values and morals, assured their safety, and helped rear them through their education.

- Obama loved and adored his wife on and off camera. His admiration and respect for his wife seeped out of him on daily random occasions and made it transparent to see that he held his wife in high regard and above all other women in his life.
- Obama led his family into membership of a Christian church where they received spiritual guidance and positive fellowship.
- Obama brought about the highest level of social harmony among citizens of American unlike any other president of the United States. There has never been a show of love between black and white people in America than during the Obama presidency.
- Never in the history of the world has other nations and countries celebrated because of a sincere, qualified black human being winning the presidency of the United States.
- Obama taught black men who were never exposed or taught how to treat their women, just by him modeling his love for First Lady Michelle Obama. Whether we like it or not, "some" of us as black men haven't a clue how to properly treat our queens and feel good while doing it.
- Obama demonstrated the difference in leading a country as a nation's leader versus being the bishop or pastor of a nation. His decisions were based on the fair governing of (ALL) people—not only black people or heterosexual people but also all mankind in these United States of America. The problem many uninformed "Simon said" type of Christians and citizens got caught up in was expecting Obama to do the job of God or a dictator. When Obama didn't make decisions that you perfect folks wanted him to make, then you hated him from that point on, still never understanding what his role was.

He didn't get it mixed up, YOU all did. It is God's job to judge the people of the world, not Obama or any president for that matter. The perfect Christians that have no sin chose two sins out of a thousand sins to hate Obama for and threw all the other sins in the trash can. So Obama chose to continue an existing bill already in place before his presidency for women to have the right to choose what happens to their body and inside of their own bodies, and the sinless Christian folks went crazy. Here's the big one—Obama then gave "millions" of gay citizens the right to marry, and Obama became the first gay black president from hell. Lol!

There's a scripture I'm sure many Christians are aware of but seem to pass those pages, scripture about the wheat and the tares, inspired by Matthew 13–30. The wheat and the tares look very similar in the field. They actually grow together. They both are given the same opportunity to receive sunlight, rain, and wind. Although the wheat is what harvests good grain and a plentiful harvest, the tares live and grow right along with the wheat.

The harvest is when the judgment of both wheat and tares are revealed in the end and reveal the differences between the wheat and the tare. It is not our job to determine who was a tare and who deserves the harvest of heaven. That is God's job. Furthermore, some of the tares are Christians who are in false disguise as being error-free and perfect, but they are identical to the wheat as the gay people who you look at as tares. So when your focus is on judging the lives of others, you may want to be absolutely sure that you are truly harvestable wheat yourself, because you may be judging tares who are identical to you as it relates to your scarred life. If I lost you in any of this example, the wheat is supposed to be good and the tares are bad. But they both look the same while in process and growth.

We live in a nation where there is a large population of gay individuals who add to the economy and makeup of America. Whether you like it or not, it is something completely out of your control. And the more time you spend on trying to change something that is impossible to change, you miss being effective in other areas of your own life that need perfecting. Here's another example that shows how long alternative lifestyle has been on the face of this earth and

the obvious fact that it hasn't gone anywhere since then. Another scripture in the Bible details a story that happened during the days of Christ. The entire scripture gives the full details that shed light on dysfunctional acts that have been going on since thousands of years ago. It doesn't make it right, but it certainly provides evidence of this being something that has yet to stop or change.

> In the city of Sodom, two angels arrive in Sodom and Lot shows the angels hospitality. The men of the city gather around Lot's house and demand that he gives them the two guests so they could rape them. In response Lot offers the mob of men his two virgin daughters instead. The men refused his offer and demanded the male guest be sent out who were the sons-in-law of Lot. The men surrounding Lot's house was not at all interested in Lot's daughters. They wanted to rape the men. Then the angels struck the awaiting men with blindness and told Lot to leave the city of Sodom with his family immediately. (Genesis 19)

Again, these scriptures are to make the point that sexual preference, homosexuality, and lesbianism have been around for ages and have not left the presence of life to this day. We do not have the power to change this. Only a person can change within himself/herself, and only God has the power and authority to change what he feels needs to be changed or dealt with. You can't put this responsibility on one black president who finally made it into a white-male-ran system of government, to change what hasn't been changed in thousands of years. Trust me, your efforts would be most effective in other areas than wasting your time on trying to change the minds and hearts of people who are determined to be who they are or who they wish to be. That's NOT OBAMA'S FAULT. Obama is living HIS life according to what HE believes. His personal feelings have nothing to do with what other people feel and want for their own lives. His life exemplifies that very point.

Obama simply gave them the same privileges that all citizens of America had, following the "Liberty and justice for all" American pledge. That is the responsibility of a country leader, not to be the judge or God of people's lives, but to govern the safety and healthy operation of life for all. For any Christian not to understand this means you're practicing hypocrisy and you're not a mature, seasoned Christian. No pastor, bishop, or church leader has any power or authority to judge anyone, nor do Christian followers. Yes, you can preach God's word, but it is ultimately up to the person and God to do any changing if any changing is going to be done.

A frustrating truth for many of you is this—gay people will be here long after you're dead and gone. So think critically about that and if your life is worth spending on trying to change the lives of others who are happy as they are. I wish I would spend even one minute on preaching and judging the lives and choices of gay people. The devil is indeed a lie. Do you have any idea how much time that takes away from my one life? I am here to live in MY purpose and enjoy every waking moment I have before my final resting place. Judging other folks' lives and being angry at a president because I don't know anything about high-level politics, history, or God's purpose over others' lives is not worth giving up the years God gave me and my own journey on earth. Give it to God and leave these people alone.

The other truth to this is most of you who are shouting the two scriptures you're upset with Obama about, I guarantee if I were allowed to do a thorough investigation of many of your past, I would find previous abortion records and receipts and some of you an alternative past lifestyle as well. Don't point your finger at people making choices for their lives, and you've made plenty of choices that would shock others who think they know you. We are all human beings full of flaws. The way to any man's or woman's ears and mind is through inviting them to be a part of God's goodness. Welcoming people as they are is what opens them up to the Word. Let God work with those individuals just as he worked with you and your previous jacked-up life. And guess what? All these points and views come from a straight heterosexual man. Therefore, none of my views relating to this are biased. Last point, take a look at Obama and his family and

tell me if he looks like he's lost any sleep over your righteous opinions or disliking of him. You will be severely disappointed.

Myth. Uncle Tom was a sellout slave.

Truth. The title and misperception of Uncle Tom have been misrepresented in America for many years. This again comes from listening to uninformed people and repeating the ignorance throughout a lifetime and infecting others with ignorance. Uncle Tom was based on the life of Josiah Henson who was born in 1789 and died in 1882. His story was made very popular and controversial by former slave Harriet Beecher Stowe. Harriet Beecher Stow wrote a best-selling novel that was a true testimony of the life of Josiah Henson, called *Uncle Tom's Cabin.* The truth is Josiah Henson was a slave for forty-one years of his life and sold to several different slave owners and used as a bargaining pawn with other owners.

He was beaten throughout his slave life and eventually escaped to freedom into the Boston area. Josiah Henson would be noted by other companies for his skilled labor and mostly acknowledged by society for helping over 118 slaves escape to freedom. He moved to Canada and made a productive life working for well-known companies and helping to increase profits for them through his talented work skills. Outside of his skill set and work ethics, he was a preacher and was very spiritual. Josiah Henson was a great speaker and would travel throughout Canada on into London and other parts of England to speak at numerous events. He became internationally known as a slave that made it to freedom and acted as an abolitionist who helped other slaves escape north to freedom.

This positive notoriety made many whites in America jealous and angry with Josiah Henson and the writings of the novel character Uncle Tom. Therefore, what American Europeans did was they reinvented the name and character of Uncle Tom. They put a totally different twist on who Uncle Tom was by tarnishing the positive history of what actually took place in his life and made him out to be a disgraceful slave. White citizens produced dramatic stage plays in theater performing in black face, making the character of Uncle Tom to be a conniving, betraying slave that would tell on other slaves and sell out his people to please the slave master. All this was done on

stage and became the new information describing Uncle Tom. This was deliberately done to erase the true history of Josiah Henson and give birth to yet another lie in black history. Please know that Mr. Josiah Henson, better known as Uncle Tom, was indeed the total opposite of a sellout slave and was a former slave that we can definitely be proud of.

Myth. House slaves had a better life than field slaves.

Truth. Contrary to stories told about the house slave having a better life, there are gruesome truths about what the house slave went through. Many of the house slaves were women who experienced rape and abuse far more than those working in the field. Being that men and women were more easily accessible to the master and his family living in the house, it was convenient for the master to have his way with house slaves on a consistent basis. Women slaves were raped on a regular basis, working in the home. A great percentage of biracial children were born from the house slaves. This history impacts us to this current day.

Myth. The census is a way the government keeps up with you so they can come get you and lock you away or kill you when they want to and allows them to get into your personal business and life.

Truth. This is false and a part of the many conspiracy theories that keep us ignorant and lost. Have you ever thought about why some conspiracy theories are created and who they are specifically for? Well, I can tell you this—many of our disparities and lack of having are due to our beliefs in some of these conspiracies. Not participating in the census count does exactly what it has done to many of our black communities. By not participating, it cuts us out of major dollars that are allocated for the elevation and development of communities. So outside of other reasons, we are all aware of from gentrification to red lining and more; having a low representation on the census leaves us out of the game that everyone else around and outside of our communities benefit from. If the government does not see the numbers to justify a need in certain communities, then they will not allocate funds to go to that community to get things done. Time to stop listening to foolishness folks and participate in

the census so that our communities can receive the same support white communities receive.

Myth. Voting doesn't matter. Black folks vote doesn't count or matter. The president is chosen by three powerful men who run America.

Truth. A bunch of foolishness. Ignorance with a bow tie and top hat. Conspiracies are designed to keep the same results happening that benefits the evils of America. Ladies and gentlemen, what happens when many of us buy into a myth that our vote doesn't matter or count so there's no need to vote? Well, what happens is we get the same results we have seen for over fifty years prior to the Obama campaign. We get low votes from the black communities, and a candidate is voted into office who cares nothing about the concerns of the black community. The conspiracies work against us and only on us black folks.

Watch what happens when you simply open your eyes and view what's in front of you. If our votes didn't matter, you wouldn't see white folks lined up wrapped around a voting site. There is something to the fact that white folks are lined up in droves to vote for who they want in office. Therefore, if you see white folks lined up all the way down the street, then you better believe you as black folks should be lined up all the way down the street. White folks are not going to waste their time year after year, term after term, lining up to vote if it didn't matter. An even bigger factor is why were the late great Congressman John Lewis, Dr. Martin Luther King, and many others during the civil rights era beaten and killed for fighting for the right to vote?

If our voting didn't matter, the white folks would not have had any reason to beat and kill us for trying to vote. All this should tell you something. Here's another factor; if our vote didn't matter, why do presidential candidates all fight to obtain the black vote? Every time you see a presidential candidate today, their main discussion is what they plan to do for the black community. Lies, promises, and photo ops are all over news and social media and geared toward the black community to convince us to go into the polls and vote for this or that candidate. Do you not realize all this means there must be

some serious power in voting and not only voting but also in OUR votes as black Americans?

Furthermore, it is beyond a disgrace for those who took beatings for us, hangings for us, and jail time just so that this generation would have equal rights to vote and be heard in America. How selfish of us to sit on our ass making ignorant comments and cheap dead-end philosophy about why we aren't voting? You are a disgrace to your own people and to the people who died for your sorry ignorant ass to give up your right to vote. Courageous individuals paid the price for you before many of you were even born. The thing that those of you who buy into this foolishness always miss is that our voting does not just impact the presidency. It impacts every level of government that we live under every day of our lives, from politicians to judges who will try your case or your loved one's case in a court of law and all the way up to the Supreme Court.

So when you speak of not voting, you demonstrate how ignorant you are to understanding how far your votes go. You are basically saying that you are a straight dumb ass and don't care who dies, who goes to jail, who gets off for killing innocent black people, and who gets a light sentence for blowing up a black church with people worshipping or a building with people of all walks of life. You reveal so much sad truths about yourself when you choose not to vote, and you become a disgrace to America. The conspiracy is designed to do exactly what it does. Keep Negros at home on voting day. It's past time to be smart folks. Get up and go vote. You don't have the right to stay home no matter how foolish you choose to be. You lost that right when people died for you. Go vote!

Myth. Former NFL star Colin Kaepernick disrespected the American flag and what it stands for by his chosen way of peaceful protest during the games.

Truth. When you take time to consider the long traumatic and oppressive journey of black people from the 1600s to the present day, highlighting the fact that blacks just got the right to vote in this very country only fifty-three years ago, one can clearly understand Colin Kaepernick's purpose of kneeling during the national anthem.

IMPACT OF AMERICA

I think we need to stop losing our minds every time someone goes against the fabric of America or speaks against what we all have been conditioned to accept, believe, and understand. It is when we go against the grain that we discover and face truths that have been replaced and disguised by beliefs and traditions.

I respect this young man Colin Kaepernick because he stood alone and did not seek or need the validation or approval of anyone to support what he feels strongly about and knows to be true. It is evident to me that he knows the true history of America and he's embracing his own history by standing for it. Furthermore, I can really appreciate the fact that he's showing America something profound if you just take the time to closely observe. America is always happy as long as no one steps out of place. As long as Kaepernick and others are throwing or running a football, dunking a basketball, or filling a major arena for entertainment, everything's fine and dandy. However, as soon as an athlete or entertainer utilizes his/her platform to wake up sleeping people, then he's a bad person in the eyes of America and stands to lose endorsement deals and a great career.

There are two types of people who don't agree or understand Kaepernick's stand, including all the clowns who booed President Obama during a game in the mid of this event.

1. The first person are the people who have never gone through anything, never experienced oppression of any kind, and never had the pleasure of meeting struggle and tribulation. Therefore they cannot relate or do not have any idea of anyone who has stood against injustice against black people.
2. The second person are the weak-minded individuals who can't break free from the conditioning chains of America and who are left to always jump on the hype bandwagon. These people will agree with whatever the majority of other misinformed people are saying and are trained to see things through tunnel vision. They never realize that the conditioning has taught and instilled in them a neglectful spirit against their own people. So they ignore the obvious and

settle for living in their oppressive conditions and bondage just as many of the stubborn slaves did that Harriet Tubman could not help show the light.

My message to professional athletes and entertainers is this—I think Kaepernick is doing exactly what he is supposed to be doing with the platform he has been blessed with. I feel it is an obligation to anyone who has been blessed to become nationally or worldly known through sports or entertainment to use that platform to help heal a nation of people. You are not blessed to be famous just for entertainment. That platform is powerful and gives you a voice that will be heard and appreciated by the masses and can actually bring about positive transformation. You have an obligation to do more than bet millions of dollars on a football game or making it rain in the booty clubs. We have to start looking closely at those who were here before us and take heed to their actions that helped deliver us out of one bad era to the next.

Harry Belafonte stood up, Sidney Poitier stood up, the Beatles stood up, James Brown stood up, Marvin Gay stood up, Muhammad Ali stood up, Sammy Davis Jr. stood up, and the list goes on. Our rappers and famous figures have more power than they are utilizing to help bring an end to much of the foolishness we continue to endure. Hip-hop culture and rap are listened to and adored by more whites and foreign people around the world today than ever before. I've been to countries where the people speak no English but are able to sing along word for word to American hip-hop lyrics and tunes. You need to use that with the same impact of a nuclear power to spread positive change. No, it is not all your responsibility to help bring about the healing; however you are a major part of what can start the process. When you speak, people listen. When you move to action, people will follow. Celebrities, due to the fact that your voices are being held in high regard, it is imperative that if you do speak, please know what you are talking about. Take time to consult with others who are well-versed in sociology, political science, history, and the injustices of America before you speak on behalf of a nation of black people.

IMPACT OF AMERICA

As for us everyday citizens, we need to demand accountability and put action where our mouth is. We need to vote and get rid of the barbershop mentality of our vote not counting. That's cheap old philosophy. You black folks should know by now after a black man recently served two terms in a white-controlled country as president that your votes indeed count and matter. If our votes did not count, Obama would not have seen the White House. Thankfully because of this new generation of people, America is blessed with a mass of diversity and a brotherly mindset, which was how Obama got into office. It was not only black votes that got Obama in. The reason the black voting numbers were not as high as they should have been is because of division among black people and because we are always distracted by a bunch of philosophical foolishness and myths that have a hold on our minds and hearts. What got Obama in was a bucket of assorted flavors, white, Latin, black, and Asian people with open minds and all wanting the same fare treatment as American citizens.

Black folks, always consider your source and who you listen to. Much of the hype, myths, and undocumented theories keep us confused, divided, and the last to know what the hell is really going on. Stop listening to foolishness and propaganda that has no proof or accessible research behind it. Instead of frowning upon a black person who takes a stand, take time to analyze what he/she is saying and where they are coming from. Know your own history so that you can recognize as soon as you see someone making a move of substance and truth. Don't read one-sided articles that only criticize the movement of something positive. One-sided articles are written by biased individuals who are against whatever movement or occurrence is happening. Stick with evidence-based information that deals with only the facts, occurrences, history, and consistent story line that lead to the cause. This is how you can trace truth and purpose without any distracting lies.

Finally, know that it is okay not to love every single thing about your country. Yes, I love being a citizen of America and thankful for some of what it offers. However, just because I like being an American does not mean that I have to accept all the negative toxic crap that it

has fed us and continues to feed us. I have a constitutional right to speak out about it or against it. That's a part of America that must be changed. We need more Colin Kaepernicks.

Myth. 5G conspiracy. 5G are those nuclear radiation towers placed in most black neighborhoods designed to come through our cell phones, burn our brains so that the government can control us through radio activity, and prepare us for new world order.

Truth. Sigh. So ridiculous. First of all, people who buy into this psychotic way of thinking, you forget that America loves your money. America is not trying to do anything to a mass of people that will stop the dollar from circulating and keeping this country rich. You also forget that black people are the second largest consumers of America, and our dollars circulate in our communities only for six hours in a day before it goes out of our neighborhood to other communities of America. Do you not realize that they love this about us? We keep America extremely wealthy. They are not trying to kill us off, folks. They use and abuse us, yes, but kill us as a whole, no.

If we are all dead from 5G, who will be around to buy all the hair and nail salon products, crab legs, lobster and shrimp, alcohol, Nike tennis shoes, jewelry, name-brand clothing, shoes, high-dollar bags and purses, high-profile vehicles, televisions, and appliances and go to clubs and bars? The money generated off all these material items and expensive dining come from black people. Black people are the bankroll of America. That's not a boast, but rather a sad reality.

5G is nothing more than an upgrade to the previous gigabytes that allow fast Internet and media. If this was as dangerous as some of you think, then the technicians installing the devices could not touch it with bare hands, which they do. If 5G was such a toxic and dangerous material, would sales persons in cell phone stores and electronic stores be around the devices all day, every day? Try going into a cell phone store full of 5G phones and give the sales person your theory about 5G and watch them laugh. Furthermore, not just one group of people would be negatively impacted by this. It wouldn't just be black people. All races would be interested in superfast speed Internet and other technology. So the theory would mean that not only black folks' brains would fry, but also all races would have radi-

ation damage to their brain or body. Sigh. It's just simply not true, guys. Stop the Simon said mentality and erase ignorance by feeding your mind. Read and research.

Myth. More whites have been killed by police than blacks.

Truth. This is an example of a lack of insufficient research and again trains weak-minded people to be drawn to inaccurate information leaving key details behind. Imbalanced, one-sided research and statistics are poisonous to a community. This compares whites who have committed crimes leading them to be killed by police where blacks—who were simply being themselves walking down a street, jogging, selling cigarettes at the corner store, or driving their vehicle—are shot and killed with no gun or weapon in hand. This poses two totally different statistics and scenarios. This should never be compared because it's simply not equal or the same. What were the whites doing that caused police to kill them? It certainly wasn't just minding their business with no weapon in hand. We can all attest to what blacks were doing who were killed by police. They were doing nothing at the time and had no weapons in their hands. The entire world has seen hundreds of videos of this fact. An accurate, fair stat would have been unarmed whites killed by police to unarmed blacks killed by police. The point is blacks have been killed by the police through racial motivation and injustice. Whites have been killed by police in the act of doing crimes that lead to them losing their life. How many videos have we seen with whites chasing police with knives and guns, only to be arrested after physically threatening the lives of police officers? This is the same behavior that has gotten whites killed by the police.

Furthermore, research of the US Census shows that white Americans make up over 60 percent of the population where blacks make up only over 13 percent of American citizens over the past three or four years. Therefore, the percentages alone make the statistic unfair and inaccurate. I strongly advise that we throw this inaccurate information in the garbage where it belongs and stop using this as a way of watering down the disparity of countless beatings and killings of black people in America. We should also stop judging people based on their history and justify that as a reason for them to be

killed unjustly. The audacity to even create an unbalanced comparison such as this is beyond disheartening and ridiculous. How many white men have been beaten on national television the way Rodney King was? Let's make that a comparison.

Wars: Who Was Affected?

America felt it to be important to be the role model or some say the police for the world, feeling the need to be the mediator or supervisor for all the world to idolize or follow. Although this could be a positive message, it has not proven to be interpreted as such by others. When we look at all the wars America has been in whether it be defensively or offensively, the question rings loudly, why has America been in hundreds of wars over hundreds of years. According to *Global Research 2017*, America has been in approximately 222 wars over 224 years. No matter what the details are for having been in well over 200 wars, what has this country done to have been involved in so many wars? What guilt or behaviors has this country demonstrated to have had to defend itself or bring about aggression to another country? The list of wars might help you answer that question. Take note of the numerous wars America had with Native American/ Indians addressing land that was not originally owned by America. Also while observing all the recorded wars, think about the money it took to fund wars and also the large amount of money that was often generated due to wars. Something to really think about especially considering the historic behaviors of America as it relates to money and power.

- 1776—American Revolutionary War, Chickamauga Wars, Second Cherokee War, Pennamite-Yankee War
- 1777—American Revolutionary War, Chickamauga Wars, Second Cherokee War, Pennamite-Yankee War
- 1778—American Revolutionary War, Chickamauga Wars, Pennamite-Yankee War

- 1779—American Revolutionary War, Chickamauga Wars, Pennamite-Yankee War
- 1780—American Revolutionary War, Chickamauga Wars, Pennamite-Yankee War
- 1781—American Revolutionary War, Chickamauga Wars, Pennamite-Yankee War
- 1782—American Revolutionary War, Chickamauga Wars, Pennamite-Yankee War
- 1783—American Revolutionary War, Chickamauga Wars, Pennamite-Yankee War
- 1784—Chickamauga Wars, Pennamite-Yankee War, Oconee War
- 1785—Chickamauga Wars, Northwest Indian War
- 1786—Chickamauga Wars, Northwest Indian War
- 1787—Chickamauga Wars, Northwest Indian War
- 1788—Chickamauga Wars, Northwest Indian War
- 1789—Chickamauga Wars, Northwest Indian War
- 1790—Chickamauga Wars, Northwest Indian War
- 1791—Chickamauga Wars, Northwest Indian War
- 1792—Chickamauga Wars, Northwest Indian War
- 1793—Chickamauga Wars, Northwest Indian War
- 1794—Chickamauga Wars, Northwest Indian War
- 1795—Northwest Indian War
- 1796—No major war
- 1797—No major war
- 1798—Quasi-War
- 1799—Quasi-War
- 1800—Quasi-War
- 1801—First Barbary War
- 1802—First Barbary War
- 1803—First Barbary War
- 1804—First Barbary War
- 1805—First Barbary War
- 1806—Sabine Expedition
- 1807—No major war
- 1808—No major war

IMPACT OF AMERICA

- 1809—No major war
- 1810—U.S. occupies Spanish-held West Florida
- 1811—Tecumseh's War
- 1812—War of 1812, Tecumseh's War, Seminole Wars, U.S. occupies Spanish-held Amelia Island and other parts of East Florida
- 1813—War of 1812, Tecumseh's War, Peoria War, Creek War, U.S. expands its territory in West Florida
- 1814—War of 1812, Creek War, U.S. expands its territory in Florida, Anti-piracy war
- 1815—War of 1812, Second Barbary War, Anti-piracy war
- 1816—First Seminole War, Anti-piracy war
- 1817—First Seminole War, Anti-piracy war
- 1818—First Seminole War, Anti-piracy war
- 1819—Yellowstone Expedition, Anti-piracy war
- 1820—Yellowstone Expedition, Anti-piracy war
- 1821—Anti-piracy war (see note above)
- 1822—Anti-piracy war (see note above)
- 1823—Anti-piracy war, Arikara War
- 1824—Anti-piracy war
- 1825—Yellowstone Expedition, Anti-piracy war
- 1826—No major war
- 1827—Winnebago War
- 1828—No major war
- 1829—No major war
- 1830—No major war
- 1831—Sac and Fox Indian War
- 1832—Black Hawk War
- 1833—Cherokee Indian War
- 1834—Cherokee Indian War, Pawnee Indian Territory Campaign
- 1835—Cherokee Indian War, Seminole Wars, Second Creek War
- 1836—Cherokee Indian War, Seminole Wars, Second Creek War, Missouri-Iowa Border War

DANTÉ CHARLES

- 1837—Cherokee Indian War, Seminole Wars, Second Creek War, Osage Indian War, Buckshot War
- 1838—Cherokee Indian War, Seminole Wars, Buckshot War, Heatherly Indian War
- 1839—Cherokee Indian War, Seminole Wars
- 1840—Seminole Wars, U.S. naval forces invade Fiji Islands
- 1841—Seminole Wars, U.S. naval forces invade McKean Island, Gilbert Islands, and Samoa
- 1842—Seminole Wars
- 1843—U.S. forces clash with Chinese, U.S. troops invade African coast
- 1844—Texas-Indian Wars
- 1845—Texas-Indian Wars
- 1846—Mexican-American War, Texas-Indian Wars
- 1847—Mexican-American War, Texas-Indian Wars
- 1848—Mexican-American War, Texas-Indian Wars, Cayuse War
- 1849—Texas-Indian Wars, Cayuse War, Southwest Indian Wars, Navajo Wars, Skirmish between 1st Cavalry and Indians
- 1850—Texas-Indian Wars, Cayuse War, Southwest Indian Wars, Navajo Wars, Yuma War, California Indian Wars, Pitt River Expedition
- 1851—Texas-Indian Wars, Cayuse War, Southwest Indian Wars, Navajo Wars, Apache Wars, Yuma War, Utah Indian Wars, California Indian Wars
- 1852—Texas-Indian Wars, Cayuse War, Southwest Indian Wars, Navajo Wars, Yuma War, Utah Indian Wars, California Indian Wars
- 1853—Texas-Indian Wars, Cayuse War, Southwest Indian Wars, Navajo Wars, Yuma War, Utah Indian Wars, Walker War, California Indian Wars
- 1854—Texas-Indian Wars, Cayuse War, Southwest Indian Wars, Navajo Wars, Apache Wars, California Indian Wars, Skirmish between 1st Cavalry and Indians

IMPACT OF AMERICA

- 1855—Seminole Wars, Texas-Indian Wars, Cayuse War, Southwest Indian Wars, Navajo Wars, Apache Wars, California Indian Wars, Yakima War, Winnas Expedition, Klickitat War, Puget Sound War, Rogue River Wars, U.S. forces invade Fiji Islands and Uruguay
- 1856—Seminole Wars, Texas-Indian Wars, Southwest Indian Wars, Navajo Wars, California Indian Wars, Puget Sound War, Rogue River Wars, Tintic War
- 1857—Seminole Wars, Texas-Indian Wars, Southwest Indian Wars, Navajo Wars, California Indian Wars, Utah War, Conflict in Nicaragua
- 1858—Seminole Wars, Texas-Indian Wars, Southwest Indian Wars, Navajo Wars, Mohave War, California Indian Wars, Spokane-Coeur d'Alene-Paloos War, Utah War, U.S. forces invade Fiji Islands and Uruguay
- 1859 Texas-Indian Wars, Southwest Indian Wars, Navajo Wars, California Indian Wars, Pecos Expedition, Antelope Hills Expedition, Bear River Expedition, John Brown's raid, U.S. forces launch attack against Paraguay, U.S. forces invade Mexico
- 1860—Texas-Indian Wars, Southwest Indian Wars, Navajo Wars, Apache Wars, California Indian Wars, Paiute War, Kiowa-Comanche War
- 1861—American Civil War, Texas-Indian Wars, Southwest Indian Wars, Navajo Wars, Apache Wars, California Indian Wars, Cheyenne Campaign
- 1862—American Civil War, Texas-Indian Wars, Southwest Indian Wars, Navajo Wars, Apache Wars, California Indian Wars, Cheyenne Campaign, Dakota War of 1862,
- 1863—American Civil War, Texas-Indian Wars, Southwest Indian Wars, Navajo Wars, Apache Wars, California Indian Wars, Cheyenne Campaign, Colorado War, Goshute War
- 1864—American Civil War, Texas-Indian Wars, Navajo Wars, Apache Wars, California Indian Wars, Cheyenne Campaign, Colorado War, Snake War

- 1865—American Civil War, Texas-Indian Wars, Navajo Wars, Apache Wars, California Indian Wars, Colorado War, Snake War, Utah's Black Hawk War
- 1866—Texas-Indian Wars, Navajo Wars, Apache Wars, California Indian Wars, Skirmish between 1st Cavalry and Indians, Snake War, Utah's Black Hawk War, Red Cloud's War, Franklin County War, U.S. invades Mexico, Conflict with China
- 1867—Texas-Indian Wars, Long Walk of the Navajo, Apache Wars, Skirmish between 1st Cavalry and Indians, Snake War, Utah's Black Hawk War, Red Cloud's War, Comanche Wars, Franklin County War, U.S. troops occupy Nicaragua and attack Taiwan
- 1868—Texas-Indian Wars, Long Walk of the Navajo, Apache Wars, Skirmish between 1st Cavalry and Indians, Snake War, Utah's Black Hawk War, Red Cloud's War, Comanche Wars, Battle of Washita River, Franklin County War
- 1869—Texas-Indian Wars, Apache Wars, Skirmish between 1st Cavalry and Indians, Utah's Black Hawk War, Comanche Wars, Franklin County War
- 1870—Texas-Indian Wars, Apache Wars, Skirmish between 1st Cavalry and Indians, Utah's Black Hawk War, Comanche Wars, Franklin County War
- 1871—Texas-Indian Wars, Apache Wars, Skirmish between 1st Cavalry and Indians, Utah's Black Hawk War, Comanche Wars, Franklin County War, Kingsley Cave Massacre, U.S. forces invade Korea
- 1872—Texas-Indian Wars, Apache Wars, Utah's Black Hawk War, Comanche Wars, Modoc War, Franklin County War
- 1873—Texas-Indian Wars, Comanche Wars, Modoc War, Apache Wars, Cypress Hills Massacre, U.S. forces invade Mexico
- 1874—Texas-Indian Wars, Comanche Wars, Red River War, Mason County War, U.S. forces invade Mexico

IMPACT OF AMERICA

- 1875—Conflict in Mexico, Texas-Indian Wars, Comanche Wars, Eastern Nevada, Mason County War, Colfax County War, U.S. forces invade Mexico
- 1876—Texas-Indian Wars, Black Hills War, Mason County War, U.S. forces invade Mexico
- 1877—Texas-Indian Wars, Skirmish between 1st Cavalry and Indians, Black Hills War, Nez Perce War, Mason County War, Lincoln County War, San Elizario Salt War, U.S. forces invade Mexico
- 1878—Paiute Indian conflict, Bannock War, Cheyenne War, Lincoln County War, U.S. forces invade Mexico
- 1879—Cheyenne War, Sheepeater Indian War, White River War, U.S. forces invade Mexico
- 1880—U.S. forces invade Mexico
- 1881—U.S. forces invade Mexico
- 1882—U.S. forces invade Mexico
- 1883—U.S. forces invade Mexico
- 1884—U.S. forces invade Mexico
- 1885—Apache Wars, Eastern Nevada Expedition, U.S. forces invade Mexico
- 1886—Apache Wars, Pleasant Valley War, U.S. forces invade Mexico
- 1887—U.S. forces invade Mexico
- 1888—U.S. show of force against Haiti, U.S. forces invade Mexico
- 1889—U.S. forces invade Mexico
- 1890—Sioux Indian War, Skirmish between 1st Cavalry and Indians, Ghost Dance War, Wounded Knee, U.S. forces invade Mexico
- 1891—Sioux Indian War, Ghost Dance War, U.S. forces invade Mexico
- 1892—Johnson County War, U.S. forces invade Mexico
- 1893—U.S. forces invade Mexico and Hawaii
- 1894—U.S. forces invade Mexico
- 1895—U.S. forces invade Mexico, Bannock Indian Disturbances

- 1896—U.S. forces invade Mexico
- 1897—No major war
- 1898—Spanish-American War, Battle of Leech Lake, Chippewa Indian Disturbances
- 1899—Philippine-American War, Banana Wars
- 1900—Philippine-American War, Banana Wars
- 1901—Philippine-American War, Banana Wars
- 1902—Philippine-American War, Banana Wars
- 1903—Philippine-American War, Banana Wars
- 1904—Philippine-American War, Banana Wars
- 1905—Philippine-American War, Banana Wars
- 1906—Philippine-American War, Banana Wars
- 1907—Philippine-American War, Banana Wars
- 1908—Philippine-American War, Banana Wars
- 1909—Philippine-American War, Banana Wars
- 1910—Philippine-American War, Banana Wars
- 1911—Philippine-American War, Banana Wars
- 1912—Philippine-American War, Banana Wars
- 1913—Philippine-American War, Banana Wars, New Mexico Navajo War
- 1914—Banana Wars, U.S. invades Mexico
- 1915—Banana Wars, U.S. invades Mexico, Colorado Paiute War
- 1916—Banana Wars, U.S. invades Mexico
- 1917—Banana Wars, World War I, U.S. invades Mexico
- 1918—Banana Wars, World War I, U.S invades Mexico
- 1919—Banana Wars, U.S. invades Mexico
- 1920—Banana Wars
- 1921—Banana Wars
- 1922—Banana Wars
- 1923—Banana Wars, Posey War
- 1924—Banana Wars
- 1925—Banana Wars
- 1926—Banana Wars
- 1927—Banana Wars
- 1928—Banana Wars

IMPACT OF AMERICA

- 1930—Banana Wars
- 1931—Banana Wars
- 1932—Banana Wars
- 1933—Banana Wars
- 1934—Banana Wars
- 1935—No major war
- 1936—No major war
- 1937—No major war
- 1938—No major war
- 1939—No major war
- 1940—No major war
- 1941—World War II
- 1942—World War II
- 1943—World War II
- 1944—World War II
- 1945—World War II
- 1946—Cold War (U.S. occupies the Philippines and South Korea)
- 1947—Cold War (U.S. occupies South Korea, U.S. forces land in Greece to fight Communists)
- 1948—Cold War (U.S. forces aid Chinese Nationalist Party against Communists)
- 1949—Cold War (U.S. forces aid Chinese Nationalist Party against Communists)
- 1950—Korean War, Jayuga Uprising
- 1951—Korean War
- 1952—Korean War
- 1953—Korean War
- 1954—Covert War in Guatemala
- 1955—Vietnam War
- 1956—Vietnam War
- 1957—Vietnam War
- 1958—Vietnam War
- 1959—Vietnam War, Conflict in Haiti
- 1960—Vietnam War
- 1961—Vietnam War

- 1962—Vietnam War, Cold War (Cuban Missile Crisis; U.S. marines fight Communists in Thailand)
- 1963—Vietnam War
- 1964—Vietnam War
- 1965—Vietnam War, U.S. occupation of Dominican Republic
- 1966—Vietnam War, U.S. occupation of Dominican Republic
- 1967—Vietnam War
- 1968—Vietnam War
- 1969—Vietnam War
- 1970—Vietnam War
- 1971—Vietnam War
- 1972—Vietnam War
- 1973—Vietnam War, U.S. aids Israel in Yom Kippur War
- 1974—Vietnam War
- 1975—Vietnam War
- 1976—No major war
- 1977—No major war
- 1978—No major war
- 1979—Cold War (CIA proxy war in Afghanistan)
- 1980—Cold War (CIA proxy war in Afghanistan)
- 1981—Cold War (CIA proxy war in Afghanistan and Nicaragua), First Gulf of Sidra Incident
- 1982—Cold War (CIA proxy war in Afghanistan and Nicaragua), Conflict in Lebanon
- 1983—Cold War (Invasion of Grenada, CIA proxy war in Afghanistan and Nicaragua), Conflict in Lebanon
- 1984—Cold War (CIA proxy war in Afghanistan and Nicaragua), Conflict in Persian Gulf
- 1985—Cold War (CIA proxy war in Afghanistan and Nicaragua)
- 1986—Cold War (CIA proxy war in Afghanistan and Nicaragua)
- 1987—Conflict in Persian Gulf

IMPACT OF AMERICA

- 1988—Conflict in Persian Gulf, U.S. occupation of Panama
- 1989—Second Gulf of Sidra Incident, U.S. occupation of Panama, Conflict in Philippines
- 1990—First Gulf War, U.S. occupation of Panama
- 1991—First Gulf War
- 1992—Conflict in Iraq
- 1993—Conflict in Iraq
- 1994—Conflict in Iraq, U.S. invades Haiti
- 1995—Conflict in Iraq, U.S. invades Haiti, NATO bombing of Bosnia and Herzegovina
- 1996—Conflict in Iraq
- 1997—No major war
- 1998—Bombing of Iraq, Missile strikes against Afghanistan and Sudan
- 1999—Kosovo War
- 2000—No major war
- 2001—War on Terror in Afghanistan
- 2002—War on Terror in Afghanistan and Yemen
- 2003—War on Terror in Afghanistan, and Iraq
- 2004—War on Terror in Afghanistan, Iraq, Pakistan, and Yemen
- 2005—War on Terror in Afghanistan, Iraq, Pakistan, and Yemen
- 2006—War on Terror in Afghanistan, Iraq, Pakistan, and Yemen
- 2007—War on Terror in Afghanistan, Iraq, Pakistan, Somalia, and Yemen
- 2008—War on Terror in Afghanistan, Iraq, Pakistan, and Yemen
- 2009—War on Terror in Afghanistan, Iraq, Pakistan, and Yemen
- 2010—War on Terror in Afghanistan, Iraq, Pakistan, and Yemen
- 2011—War on Terror in Afghanistan, Iraq, Pakistan, Somalia, and Yemen; Conflict in Libya (Libyan Civil War)

- Let's update what's happened since 2011:
- 2012—War on Terror in Afghanistan, Iraq, Somalia, Syria and Yemen
- 2013—War on Terror in Afghanistan, Iraq, Somalia, Syria and Yemen
- 2014—War on Terror in Afghanistan, Iraq, Somalia, Syria and Yemen; Civil War in Ukraine
- 2015—War on Terror in Somalia, Somalia, Syria and Yemen; Civil War in Ukraine Global Research (2017)
- 2018—War Attack on Syria for nuclear arms control (Wikipedia.org/wiklist of wars invvolving the united states); Heidelberg Institute for International Conflict Research.

The wealth of the wicked comes from studying and manipulating black people for their benefit, from the slave crop fields to the gifts, talents, and labor of black people to this day.

Blacks are currently and have been the second largest consumer in America. African Americans have an estimated spending power of $1.5 trillion. Combined with other minorities, like the Asians and Latinos, their estimated collective spending power is around $3.9 trillion.

When Asians came to America and generated wealth by selling based on the interests and characteristics of black people, it proved who the largest consumer of America was. No one spends money on nails, hair, and other beauty products and also rice, broccoli, chicken, egg rolls, and sea food at the level that black people do. Add in popular high-end sneakers, jewelry, and name-brand clothes, black people corner the market in buying power. However, the wealth that Asians have gained from studying the interests of African Americans should not be looked at as wicked. To me I see it as cleaver business practice and being smart enough to be attentive to a culture who spends money on the things they desire. Rather the wicked are those who manipulate African Americans by promoting demeaning and degrading fashion that maintains a nonproductive mindset.

Examples of normalizing negative clothing trends is the manufacturing of clothes that are designed to sag showing the buttocks of men, promoting the wearing of pajamas in public, along with designing house shoes to be worn outside of the home—to the mall or supermarket. All of this encourages a classless mindset and the practicing of a lower social class. Making this inappropriate way of dressing in public to be acceptable and creating a market for it add to the nonproductive mindset of a people. Now house shoes are designed and perfected to be worn out in public to any event or establishment and the same with pajamas. It becomes a normality so many can't identify with its dysfunction.

Slavery and Trauma

Europeans invaded African lands and utilized many of the same strategies they used to conjure Indians or Native Americans out of their land. The most effective method used to kidnap and abduct African men women and children was the powerful method of divide. "Divide and Conquer" was the powerful tool used to steal Africans from various areas of the continent and had an impact on the black community and society to this very day. One of the biggest misunderstanding people have about Africans being captured into slavery during the 1600s is the misguided details of Africans selling one another into slavery. To hear people using this small piece of information as an excuse or diluting of that traumatic event is evidence of the level of ignorance people have about history and it says even a sadder reality for those black people who buy into this without understanding the full story and dynamics of how Africans were manipulated.

Multiple tribes have always existed in Africa; however that never led to selling anyone into slavery because the idea of slavery in another land was never a threat or method of weaponry against another tribe until Portuguese and other Europeans brought the idea to western Africa. What people fail to understand or include in the selling of slaves by other African tribes is the fact that Europeans set the stage that inspired and motivated tribes to sell other African tribes into slavery.

It is very irresponsible and misleading for people to talk about Africans having sold other Africans into slavery without including the key element to this taking place. African tribal members and families would hunt for food to feed their families, and this would take from

two weeks to a month to hunt animals and food to last them for a reasonable time before hunting again. Europeans offered Africans guns, gun powder, clothes, iron, and other valuables that would benefit their families. This level of divide was new to the African culture, just as the idea of being able to cut down their hunting from two to four weeks to only a day or two by shooting their prey with weapons called guns.

This was the poison that took African tribes to a critical level of deceit and the beginning of a new career for African tribes as African slave traders. This same level of divide continued on into the processing and rearing of slaves. In other words, Africans and their lack of modern tools and access to modern weaponry were used against them for Europeans to accomplish their agenda. The methods of divide and conquer, manipulation, and using impoverished conditions as a manipulative way of taking control of millions of Africans were taught to the Africans by the very traumatic experience they endured from the captors. It is also important to know that any slavery that took place before Europeans came to Africa was a completely different method of slavery.

There was no racial element of white and black, and slaves could marry, own property, and did not remain slaves after a certain age or period. These same valuables and tools were used in the manipulation of Indians and Europeans stealing their land. One of many fairy tales America taught us was that Christopher Columbus discovered America. However as more inquisitive people were born, America evolved into a more conscious society that revealed the truth of Columbus and discovered that Indians were on land first and managed those lands well. Christopher Columbus and his army manipulated the Indians in the same way Africans were manipulated and stole the lands from the Indians through trickery and aggression.

What we must understand as a part of truth is that no matter how negative and traumatic the kidnapping was and the selling of slaves by other African tribes, all those African traders could comprehend was the fact that their lives were made better by the tools and weaponry they were receiving on a regular basis through a business relationship. This became a proven method the European knew would work throughout the slave history.

The Boat Ride, Plantation, and Trauma

Many Americans have heard the details of the transportation of slaves from Africa into the Caribbean Islands and American land. However, there are factors that inflicted intense trauma on the African people before even reaching American lands. Mothers, fathers, husbands, wives, sisters, and brothers were all stripped from their loved ones, often never seeing them again in life. Once on the ship, Africans were stored as cargo, not humans. Africans were chained on their backs, lying right next to each other with no room for comfort, turning, or adjusting. Because Africans were considered to be only three-quarters human, they were treated as livestock and stored with no clothing and very little food and water.

During the sixteenth century, traveling from Africa to the Caribbeans and American coast would take one to six months depending on weather conditions, and after the nineteenth century, the journey took six weeks or more. Considering this long journey, the slaves would be sick for various reasons—some from natural causes while some from diseases the Europeans brought over to African lands. Contributing factors to illnesses on the ship was common body fluids and unmanaged hygiene, such as women's menstrual cycles and the release of feces. Women would bleed and grow ill from cramps right in the midst of other slaves. Temperatures were always extremely high, so bacteria was high and spread throughout the ship. All this created more diseases and caused death of slaves, often lying among other suffering Africans for numerous days or weeks before being thrown overboard.

IMPACT OF AMERICA

Many slaves died during the brutal capture, but the bulk of deaths occurred on the ships during the journey. Another way slaves died during the journey was from those who were free from their chains while doing labor on the decks and refused to go through a life of serving Europeans and never seeing their families again and chose to jump overboard than to remain in slavery. Other slaves were chained to each other and thrown overboard randomly by greedy slave dealers who purchased more slaves than what was permitted. If they were caught with more slaves than what was allowed on one ship, then they would have to answer to laws and financial consequences. They would chain multiple slaves together and throw one over, which would pull all those that were connected overboard and into the sea at one time before getting caught with numbers beyond what was permitted.

Although homosexuality existed long before Europeans introduced it to western African slaves, it was a foreign abusive method used against slaves. Before the plantation trauma of breaking slaves, men were raped by Europeans while on the ship journey. African males who had never experienced homosexuality or sexual aggression toward them were abused and sodomized during the journey. By the time Africans made it to plantations, there was already a level of fear of European/Caucasian slave owners. On the plantations, methods of breaking slaves included brutal rapes among men and women and numerous other physical abusive acts done to slaves.

Wives, daughters, and mothers were taken from the home against their will by slave masters and their sons for the master to have their way with African women. Many layers of trauma occurred repeatedly as damaging cycles over hundreds of years during the slave era. Over time and poisonous conditioning, African women who were taken from their homes by the master and his sons eventually would begin leaving the home on their own to meet with the master or his son. After countless rapes and unwanted advances, many female slaves ended up falling in love with their masters or their sons being that they were the only ones allowed to have them intimately until the master released them to be with their mate or lover.

This destruction of the home caused the men to become angry and hostile toward the African woman. Many would take out their frustrations on the woman because they could not take their anger out on the master or his sons. This was beyond damaging to the relationship between the slave husband and wife because the man had nowhere to show and prove that he was indeed the man. This abuse transferred on to the African men by them showing that they were the man and in control of their own home by abusing the wife to remind her that they were the men and head of their home. If they could not prove this point to the master or a new American society, they would abusively make it known in their home ignited by anger, frustration, and a depressed feeling of being emasculated. Not only did the master divide the home through rape and taking the woman from the home anytime they wanted, but also they positioned the women as being the decision-makers of business for the home. The master would never conduct business with the man of the African home because that would put the African male in the position of being a "man" and head of his house, and that would go against the conditioning that was being taught to the African family by the master and the slave process.

African men could not be considered men or in any role as the head of the family because the system of making slaves was to always to keep all African men in the mindset of being only boys. The term boy was what the master and other Caucasian slave owners called the African male to remind him of being less than a man. This destruction of masculinity and power was constantly witnessed by African women and children, which taught the entire society of African slaves to fear slave masters and the Caucasian male.

The second most powerful concept next to the methods of breeding slaves was teaching religion and beliefs of religious principles to African slaves. The purpose of this was to keep slaves under control and from ever getting ideas of uprising to gain their freedom. They conditioned the mind of African slaves with the powerful messages of the Bible and equated Jesus and God to that white males. Therefore not only were African slaves fearful of the master because of intimidating methods such as abuse, lynching, and murder, but

also they had a respectful fear of the master because the teaching of Jesus and God was equated to their own slave master.

Now slaves feared to do or say anything toward their master because psychologically he was next to God himself according to what was taught to the African slave. Because of this conditioning for over hundreds of years, a white Jesus became very real to African slaves, and all the religious teaching by the European and the Puritans became real to the African slave and was the only holy value they knew since being abducted from their own land in Africa. There is trauma through every aspect of the slave journey from the 1600s to the present. As a slave, they were manipulated, divided from each other, put against each other, raped, given stories and a God to follow and believe in, and then had to rely on the same Europeans who traumatically oppressed them to also feed them and provide shelter and clothing and opportunity in an American land that was foreign to the African as well as the system they were forced into. Therefore black people were set up to fail from the very beginning of being forced into America. America actually had a civil war between the North and South to determine if the South would keep enslaving black people or lose to the North for allowing blacks to be free from slavery. Money made off the blood and sweat of slaves, who were treated as animals, was a high demand in the South.

After slavery, the blacks did not experience true freedom until the nineteenth century, and even then they continue to struggle undying racism. Shortly after slavery, the blacks were never accepted as being free and faced the same traumatic experiences from racist Caucasians throughout numerous years of lynching, hangings, burnings, shootings, and rapes all within the United States of America. During the civil rights period, from the late 1950s to the 1960s, the blacks in America were killed just for wanting rights and equal justice. White Americans who shared the vision of peace and equal rights were killed for supporting black Americans. White supremacy and other racist groups against black people were allowed to run rampant throughout America causing deaths and injustice to the black community.

Black Americans were killed for expressing their right to vote, eat inside restaurants, and eat at counters as other patrons instead of being sent to the back of restaurants by the dumpsters. Black Americans were beaten and lynched just for wanting to eat in restaurants like other people. Restrooms, water fountains, and dressing rooms were separated by whites only. In this same country, more than one hundred Black men were neglected of being treated for syphilis during an irresponsible and unjustified experiment done by whites in Tuskegee, Alabama. Numerous traumatic events continued on into the modern years. Injustice and abuse continued to the present day wherein black men are beaten to death, choked to death, and shot and killed in cold blood with no weapons in their hands by white police officers, this being witnessed by onlookers with cameras. And this country still allows racism to win over such massacres and crime.

Homosexuality

Homosexuality was a hidden issue in the black community due to its root of slavery, trauma, and behaviors that followed from hundreds of years of sexual abuse and oppression. Numerous men were broken as a part of slavery, and the mothers became accustomed to raising their boys to be characteristically weak and in fear to keep them alive or never being looked at as a threat by the master. So mothers began raising boys softer and having a respectful fear of the master. This was also induced again by religion taking on a humble and "meek" mindset toward issues requiring firmness and the strength of a man taking a stand. Of course this did not negatively impact all black men, but it impacted a great deal of black men throughout the oppressive journey from slavery to the present day.

Just as many women were turned from wanting their own husbands or lovers, some men were impacted as such by becoming immune to their abusers, causing them to lose the mindset or behaviors of a man. The other big picture here is the oppressor inflicting all the abuse and trauma was obviously saturated with evil, diseases, and dysfunctional behavior that was evident of mental disorders. Research shows that Africans did not suffer from diseases or alternative sexual acts in Africa. All this was learned and contracted after being taken captive and kidnapped from the lands of Africa. There are stories of homosexuality existing in Egypt among Egyptian royalty from 2000 and 2400 BC, but there is no solid evidence of this outside of illustrations and claims.

Light Skin and Dark Skin among Black People

Having light skin and dark skin is another major issue in the black community that derived from the divide during slavery. First it is very important to acknowledge and face the fact that black people of all shades—light, dark, and in between—are some of the most beautiful people on the face of this earth because of the various complexions within our melanin. However, psychological conditioning destroyed us as a people and controlled us as well. Negative conditioning that taught us about light and dark has hurt us as a people here in America and has been carried over to all corners of the world. We were deeply conditioned through slavery and years after slavery that light was equivalent to beautiful or better. Dark was equivalent to ugly or evil. This was taught to us verbally, psychologically, and visually. Through books, magazines, television, and derogatory treatment throughout life, we have all been taught to promote the divide and cherish and uplift the light skin.

After decades of living through a society that only highlighted white women or light-skinned black women in magazines and television shows, it trained the average mind to believe that these were the only people who were beautiful. This created self-hate among darker-skinned black people and generational bondage of low self-esteem. This also created a divide among black people and caused a lifetime of inner racial abuse toward each other and negative competition within the same race.

Some derogatory labels and comments describing dark-skinned blacks referred to by other blacks include the following: jigaboo, tar

baby, charcoal, dirty black, ugly, blackie, sambo, burned, field nigga, you pretty to be dark skin, and you would be handsome if you wasn't so dark. These were titles used by lighter-skinned blacks against darker-skinned blacks.

Light-skinned blacks had struggles as well with their complexion, which proved that blacks as a whole were oppressed and divided in multiple ways outside of the direct acts of slavery. Light-skinned blacks struggled with feeling accepted by the black community and being rejected by the white community because of the half portion of them being black. They also suffered from the negative envious behaviors shown toward them by whites who hated the idea of them having white and black biracial blending.

The saddest reality of all is the white supremacy mindset and the hatred bread through slavery and white supremacy in America are global oppressions. Global oppression is one of the many impacts America has had on other countries across the world. The same hatred of darker skin color exists in other countries with the same poisonous mindset downing or cursing the darker complexion. The ignorance and hatred of lower-class white Americans created a divide and hatred all over the world between the complexions of people within the same race.

Some of the negative comments and mindsets toward light-skinned blacks include the following: mutt, wetback, zebra, wannabe, high yellow, light bright, and almost white.

The hatred mentality of light-skinned and dark-skinned black people is only another agenda created by slavery and white America. One of the many flaws we carry as black people is following the agenda of racist white Americans. We have always been blinded by it to this very day. We have adopted many negative characteristics and ways of thinking from the teachings and behaviors of racist white America. By taking on a negative divide within our own people, it set us on auto pilot to hate one another with the same purpose that originated from oppressive acts of slavery. Teaching us to degrade one another and look at one shade as unequal or bad from the other allowed their hatred to live on inside of us.

What we as black people don't realize is we were infected with the same oppressive way of thinking, the same abusive treatment, and negative mindset toward one another that was designed against us. We have embraced the very tool that was used against us to use against one another, self-hate. During slavery, lighter-skinned babies were initiated to hate through rape, manipulation, unfair bargaining, and continued reproduction and then separation of light and dark. However, what white America never expected or never saw coming was that it would only create multiple shades of black, making us the only powerful example of melanin the world has ever seen.

They created yet another reason to hate us more and didn't even realize it. They contributed to creating an assorted array of complexions that doesn't need sun for tanning. There is power and beauty in different shades of black, whether dark skin or mixed; the melanin in the skin is amazing. Not only does melanin provide beautiful shades of color, but also it provides talent, strength, and wisdom. The reason we are the most talented people on the face of this earth is because of the godly power in the melanin of black people, dark and light.

The biggest reality that is missed in this entire circle of light-skinned and dark-skinned black people is the fact that every day when you observe the visual image of black people, you see clear evidence directly related to one of the major processes of slavery. The point is instead of continuing to be conditioned into the stupidity and hatred created by dumb hollow-brained redneck Americans, we should be embracing the lifelong advantage that came out of the process. We should be embracing, loving, and proudly representing the multi shades of Blackness and realize that this is an attribute to our entire race of people, not just the light skin or the dark skin.

We have all been hated for the fact that we possess an amazing variety of complexions that are truly beautiful even in the eyes of those who hate. For any black person, light or dark, to choose one over the other as being better is just as stupid and warped-minded as those who oppressed us and started hate and division among blacks. The beautiful thing about God's purpose and his people is his purpose always ends up conquering all and destroying man's original ideas.

IMPACT OF AMERICA

The divide in this day and time is due to light-skinned men and women being put on pedestals to represent the ultimate beauty just as white women were put on pedestals to represent the idea of beauty over all women prior to the 1990s and 2000s. Therefore the history of society's mindset canceling out all other darker shades of men and women to only lift up light skin as being the chosen shade to represent beauty has continued to be the oppressive mindset and negative feeling among black people today. What I have discovered as an independent thinker with my own ideals is only those who chose to allow their minds to be raped with negative conditioning and self-hatred are those who will continue to follow and promote light and dark hate.

Those who chose to elevate their mindset and their character are the only ones who will see beyond what we have been trained to see and find the true beauty within a person's character and personality. Only an independent thinker will see that there is power in the melanin of black people covering all shades from dark, browns, tans, peach, mocha, cream, and light. Only those strong black people will rise above the brainwashing and speak out against other lost blacks who continue to inflict ignorance through misunderstanding complexions/shades of black. Being a black individual who's mixed does not cancel you from being black nor does it erase your Caucasian or European side. The hue is in the blackness, and all the beautiful mixtures simply add to the hue. This brings about the shade and complexion in the melanin. Whatever one identifies as does not give the right nor the accuracy of hating the other part of their DNA. Those who seem to have no mixture does not make you blacker than anyone who may be mixed with another race. To hate another for being different is foolishness. To hate within your own race of people for being a different shade is just damn stupid.

What fools we have all been to allow a system of society to dictate us what to consider beautiful or acceptable. Even as I traveled to different parts of the world, I have noticed how America has been the poor idolization from other countries. Everyone wants to be like America when it comes to our fashion, entertainment, beauty, and what's considered trending. The light and dark division exists also in

other countries, and you see it all over their televisions and magazines just as you did in America during the 1960s and 1970s. If they are not light or white, then you won't see them representing that culture.

This is an unfortunate conditioning, and we have to admit to ourselves that the conditioning can only be carried by those who have shallow minds to follow. Only the weak follows what a system dictates to be acceptable or in this case beautiful. The fact is not to be ignored that, yes, we have some of the most beautiful light-skinned people on the face of this earth, but that was never to negate that there are just as many flawless dark-skinned and brown-skinned people as well. There is no problem acknowledging beauty. However there is a terrible problem making a division of shades and choosing what the best is by one's opinion.

Some countries with high population of dark-skinned black people have even taken bleaching to another level, all inspired by the stars, entertainers, and models highlighted in America. So when we look at the bigger picture, we see that America not only created this division among black people in America but also inspired the same negative mindset on to other countries. This is how powerful conditioning is when inflicted upon weak-minded people. In all actuality, truth, and realness, every shade there is in the black race from jet-black dark skin to the lightest skin are all absolutely beautiful because of the natural and permanent tan that is within the melanin. The most beautiful people within the black race are the ones whose beauty shines from within and who can see beauty with their own eyes and not through the eyes of a messed-up society. This person can be any shade on the scale (true beauty).

Skin Bleaching among Black People

Skin bleaching among black people is a direct sign of self-hate. American society has taught blacks and all of America to equate beauty with either white skin or lighter skin complexions. This again is powerful conditioning, placed in the eyesight and embroidered in the mind that lighter skin is more attractive. The saddest truth of all is that not only has this mindset poisoned America, but also it has spread into other ethnic countries around the world. Skin bleaching has become a widespread global phenomenon and has long been adopted in the Caribbean Islands and even parts of Africa. The average human mind gravitates toward something is interpreted or labeled as being cool, trendy, or beautiful.

Therefore, because of the impact slavery left on blacks as it relates to light and dark, we show clear evidence of still being brainwashed from thinking one is better than the other. The mind has been raped and manipulated to follow whatever society says is better when, in all actuality, different skin tones among black people make them beautiful to look at as a whole.

When Michael Jackson's outer being was forced to face his inner being, what did his lighter skin really do for him when comparing it to his inner struggles? Although his true reason for having lighter skin was because of loss of pigmentation (vitiligo), society forced him to turn the skin disease into a self-esteem issue of bleaching, becoming a person he wasn't born as.

White Privilege: Understanding and Examples of What White Privilege Looks like Then and Now

The entire system of America is based off white privilege simply because white America designed and structured the system and society of the nation. Because Europeans and white Americans always had control of media, system of beliefs, political power, and rights of citizens, all these systems and laws were designed to cater to a white-controlled society. Proof of this revealed itself during the civil rights era, showing us that there were no equal rights and there was no justice for all—only rights and equality for a white society who again created the system of America. Evidence also revealed blacks and other supporters of black people were killed and lynched for fighting for voting rights and equal rights in America. An eye-opening reality is the fact the blacks just got the right to vote in America only fifty-four years ago to the year of this book was written, 2019–2020.

Evidence of White Privilege on a National Level

So blacks literally just achieved the right to vote in recent times. Further historical evidence reports a time when blacks had to go to the back doors of the restaurant kitchen to purchase food, while whites were invited inside the restaurants, seated and served like human beings. Imagine paying for your food and receiving it at the back door by the dumpsters and not being allowed to be seen inside the restaurant you are paying money to.

Painful examples of this live on through every state of America today through politics and laws that don't apply to blacks and minorities the same way they do to whites. Blacks and Latinos have been incarcerated for petty crimes and drug charges with long sentences versus white males incarcerated for the same crimes with much shorter sentences. Unarmed black men and women have been abused and shot and killed by police officers in America, who got off from charges by the same judicial systems that are supposed to protect all citizens no matter their race. Student grants that were put in place to assist minority students to pay for college have been shortened and some taken away, leaving it difficult for low-income and middle-class minority students to afford college education.

White males in the political, religious, and entertainment arenas and corporations who have committed sexual harassment, sexual assault, rape, child molestation, and more have been seen and known for what they do but never questioned, reprimanded, or forced to answer for their criminal acts; however, when a black man commits less of these, he is crucified as if he is the devil himself. America

praised and literally worshipped Mr. Hugh Hefner, former owner and creator of the famous Playboy Mansion, the biggest whorehouse in America that invited underage females and predators for years and operated legally and uninterrupted. America praised this operation and its founder for the entire life of the Playboy Mansion and never questioned any of the illegal acts that went on inside of this famous house. Why? Because it was white-owned, white-operated, and patronized by numerous white male power figures of America with a number of famous black figures sprinkled in the mix. Therefore who's going to question you or enforce laws upon you when a part of the very system is taking part?

The Catholic Church has had a lifetime of destroying the lives of boys, yet America or no other part of the world says nothing because of how powerful the Catholic Church is financially and politically and because it is run by European males. White men could give a police officer a hard time and never have to worry about being arrested or shot, but if a black or Latino asks one question about their rights or what the police is pulling them over for, then they are immediately viewed as being difficult or giving the officer a hard time and stand the chance of being arrested, abused, or killed. All these are examples of white privilege, and if it makes you as the reader uncomfortable or feel in disagreement, then you need to examine yourself as being a part of the white privilege.

Modern-Day Field Slave Replica: NFL and NBA

The most powerful entertainment organizations in America are owned and operated by financially powerful white men who pay young men to perform a sport to entertain the world. It is a fact that black men are the most talented and athletic human beings on earth. It is in the DNA and natural ability of black men to be extremely talented in sports and theatrical entertainment. This is certainly not a negative fact about black people. This is why black men have dominated the sports of football, basketball, track and field, and even other sports that they aren't as interested in. The purpose of all facts in this book is to show the impact of America, and in doing so, the content shows what happens to a world that is controlled by one system and the cycle of consequences and results that comes from a one-sided system. Therefore the professional teams of America provide amazing financial benefits to these athletes, but some often look at this as a modern-day slavery.

When you analyze situations beyond the game or the playing field, it does make one ponder if this really is modern-day slavery. For example, when any professional black athlete speaks out on political or racial injustice or inequality or human rights, he is reprimanded or warned about how far he can go to speak on rights he believes in. If it is dealing with racial equality or protesting for oppressive acts done toward black people, that athlete is told how he can and cannot protest, what he can speak on, and what kind of protest he can or cannot do. In other words, a clear message is sent to professional black athletes in America—just focus on running the ball, throwing

the ball, dunking the ball, and winning the game and keep your mouth shut when it comes to how you feel about what's being done to your black people in America or pay the franchise big fines or sit out games and lose pay.

This is basically more control and the higher power controlling the lives of the athlete by placing fear in him by threatening to lose major dollars and not stand for what means so much to him and his people. How can this be fair? It's not at all. You don't have white men protesting or standing up for their rights in any of these entertainment sports simply because white males are not going through any struggle of abuse, police brutality, or injustice in America that they have to fight for. White males are a part of the system that has been designed for them to win. Colin Kaepernick will be a name remembered in history far beyond any players because this one black football player took a stand against the injustice of black people in America. The NFL made an example out of him by taking away his career for standing up for the lives of his people. Nevertheless, Colin Kaepernick has the last laugh because his name will be remembered in the history books long after the coaches, owners of the NFL, and all the players are long dead and gone. This leads you to ask the question, What's more important? This proves the point of these sports organizations operating like slave masters regardless of the players getting big paychecks. The sad point is, in their minds, the game and an American flag that doesn't mean what it is supposed to stand for mean more to these powerful men than equal justice and protecting the lives of innocent black people in America.

Prison System

The prison system is another form of modern-day slavery. Private organizations owned and operated prisons and used prisoners as free labor or given limited pay to meet the contractual needs of other organizations and often work done for the city or county where the prison is located. These private owners receive a huge sum for each individual prisoner; therefore, the longer they can keep an inmate, the more revenue that inmate generates for the prison owners and prison system. It has been proven that children who are difficult to teach or manage are counted in a survey during the third grade based on how they score on academic test and achievement goals. This determines how many beds and cells to build in prisons. In other words, the investment for private prisons is very profitable, and they continue to build them based on the probability of young boys and their lack of success rate in elementary and middle school. This also leads back to black males who are incarcerated with unreasonable charges and time to serve based on petty drug crimes. The money is in the time served.

The Tuskegee Study: Black Men Recruited for the Study of Syphilis

This horrible act was done in America from 1932 to 1972 by the United States Public Health Service (USPHS). Instead of using lab monkeys, mice, or other test animals, they decided to experiment how untreated syphilis would affect black men. Think about that for a minute. Out of all the other options they could have chosen to test a disease on, they chose black men. Tuskegee Syphilis Experiment. This same governmental health agency told the participating black men that they were "being treated for 'bad blood,' a local term used to describe several ailments, including syphilis, anemia, and fatigue" (https://www.cdc.gov/tuskegee/timeline.htm).

A number of black men who participated in the study already had syphilis, while another portion did not have the disease. Because this study went for so many years, the number of those contracted the disease grew. When the USPHS lost funding for treating the disease, they still continued the experiment without telling the participants that they would no longer be treated for the disease. Black men went on receiving the disease with no treatment and was told that they had "bad blood." This became one of the leading causes of death for black men in the southern African American community of America. An unethical and senseless study that was supposed to last for only six months lasted for forty years, leaving several black men with an untreated disease that became fatal in most cases.

To stand face-to-face with an individual who has a disease and you hold the cure in your hands to rid the person of the disease, yet you deny them the cure is just as bad as injecting them with the disease, in my opinion.

Cancer

Cancer is the leading health epidemic in America and known all over the world. America has the largest epidemic of cancer in the entire world. Why? Why is America the only place on the entire planet that has human beings dying every day from cancer at rates far more alarming than anywhere else globally? When you consider all the numerous types of cancer, cancer research, medical tools, equipment, operations, and procedures, it's not so hard to believe that cancer has become the biggest booming business in America. There are so many outlets to justify money for research and procedures. Anything surrounding cancer research is definitely never questionable, and trillions of dollars are made in America from the entire network of cancer.

American citizens catch cancer by the hour and die every single day from the disease. However, no other country has an outpour of cancer cases and multiple deaths related to cancer. I assure you that as America has tainted everything in its own country, America will find a way to spread this epidemic into other countries around the world to generate even more money. Sounds ridiculous and cold for anyone to think that any system of country and government would do something like this, right? Well, I ask you again, What other country has this same epidemic? What other country irresponsibly experimented on its African American citizens? I could go on.

The proof is present and right out front. There is no hidden evidence. It's all in front of anyone who is a human being with a brain. According to the US Census, there are approximate 327.4 million people living in America. Therefore, there should be a great number of farms and farmers producing good food and livestock to meet the

demand of the population. Unfortunately, this is not the case. The reason is that America wants the demand met quick and fast and has created artificial farming to mass-produce food and even meats. This is where a great deal of unhealthy living comes in for all Americans. Instead of hiring more farmers and promoting the career of farming to produce more skilled farmers, America has turned farming into a manufacturing operation with processed foods and unhealthy methods of reproducing food that goes directly into our bodies. This is one of the reasons why cancer has taken over America's population. It is in the food we eat, which is often not food at all.

Some harmful factors that makes America the leading epidemic of cancer cases are unhealthy hormone injections in meats we eat for larger meat parts, indigestible food fed to cows and other livestock to force faster reproduction and growth, chemicals being sprayed over vegetables to give longer appearance of life and color, cloning food and animals which is totally unnatural to be eating something that has been duplicated and digesting it into our system. All of these lead to various forms of cancer. Add stress and keeping up with American social trends and demands to be of a certain image and achieve accomplishments to make you look a certain way or appear to be something that you are not also lead to the fatal disease.

We have seen in television and on social media and in travels the poverty so many people live in outside of America and certain poor countries, and we judge without being critical. We look at how less they have compared to us, and we immediately say a short quiet thank you prayer in gratitude for being an American and not living under those conditions. However, we never pay attention to the fact that many of those poor people have no stress of being poor and are laughing and enjoying their lives just as we do here in America. The difference is that they laugh and enjoy their lives without any shame, guilt, facade, or fakeness. They are not faced with the stresses of trying to be like who they see on TV or keeping up with the next person. And they don't worry or stress over having cancer or wondering how they will get rid of it. So when you look at those same poor foreign countries now with a more genuine and realistic eye, you realize that they just might be better off than we are.

IMPACT OF AMERICA

What is always amazing to me is how the medical and pharmaceutical industries behave exactly like the Puritans did in the sixteenth and seventeenth centuries as it relates to natural remedies and negatively toward doctors who study natural medicines. We are judged and advised heavily against anyone who teaches, promotes, or encourages citizens to take natural remedies of the earth to help destroy cancer or other major diseases that have been doomed of having no cure. How similar these two eras are. The Puritans were a religious group who were so controlling and brainwashing that they would even kill those who practiced making natural medical healing remedies because of the same reason being spoken against today. It threatens the financial income of the medical and pharmaceutical industries. Therefore any talk of healthy natural cures is immediately shot down as being foolish, mythical, noneffective, or witchcraft. There are a great number of conscious-minded people who are well aware of the healthy choices of natural medicine. However, we still have millions upon millions who are trained to uplift chemical drugs only no matter what the side effects or financial motives that's attached to the pharmaceutical industry.

The Salem witch hunt is an excellent example of how desperate and cruel the American society and pharmaceutical industry were against human beings who threatened the market with natural remedies.

When looking closer at this example, black history really should just be called American history. Thousands of events involving black people shaped and molded this country and flowed throughout the existence of America.

Tituba was a female slave snatched out of Barbados and brought to America. Tichiba and the Salem witch hunt that occurred right here in the state of Massachusetts of good old America in 1692.

First, it is important that you know that many terms that have been taught to us as being negative were just another fallacy to detour us from the truth and hide their deceit and selfish gains. The term "witch" was once a positive term to describe midwives and ancestors who created numerous natural remedies to heal the sick, the lame, and individuals with diseases. This was a practice that many ances-

tors were capable of, and it defied the works of European medicines. These labeled witches hurt the medical economy, making the industry angry and revengeful. Puritans and European males turned the word *witch* into a negative, by labeling all midwives and others who practiced healing as witches and evil black magic workers. The term witch did not originally equate to anything bad or evil.

Tichiba was the first slave arrested and labeled as such because of her ability to heal through natural minerals from the earth. All other women found during the hunt that were suspected or accused of natural healing were tied to trees and burned alive for the public to witness. There are several inconsistent stories and fairy tales about this that hide the truth of course, but evidence lies in most research libraries.

RIP Tichiba and other healing ancestors. They were just another group of ancestors who contributed to this country in a positive way and were killed simply because of their God-given gifts and talents. So all of you who had grandmothers and great-grandmothers who created healing solutions from items straight out of the backyard, refrigerator, and cabinets were all witches. The term isn't too bad now that you know the truth about its origin.

The stories we've heard in this day and time about certain doctors and scientist mysteriously dying of natural causes or common diseases, all of whom claimed to have found the cures for cancer and other deadly diseases, are not hard to believe once we understood the culture of America and its hunger and determination to maintain secrets for its massive financial gains. Ironic how those who truly discovered natural medicines to cure America's biggest medical epidemic always end up dead. Interesting to say the least.

Survival and Adaptation

What I find to be a remarkable quality about black people in America is they refuse to be left out of anything that is meant for the enjoyment of life. If luxury vehicles are made for a certain social class of people and who can afford it, you better believe we will find some kind of way to pull up to the red light in the same vehicle next to someone making ten times more than us.

I have no idea how car notes are being paid by some of these individuals or how they are able to afford a vehicle that may be twice the price of their home, but we find a way to do it. This is just one example, but what I've always noticed is the low income of America creates their own happiness within their means. That's a positive thing.

If a low-income population cannot afford the Benzs, BMWs, Bentleys, Infinities, and Lexus, then they make due by taking the older vehicles twenty, thirty, and forty years old and refurbishing them to the point of being better-looking and cleaner than when the vehicle was new. They make the beauty shine and categorize the vehicle as a classic. This takes away any negative feelings of not being able to afford any up-to-date luxury items because the time it takes to refurbish and beautify an old car and the money that goes into it demand for all heads to turn when it pulls up next to a late-model Benz. This is a part of adaptation.

The reason black people never stress over the economy, layoffs, or who's in the presidential office is because all of our lives, we have been treated as second or third no matter who was in office, and we always made it through under any circumstances America placed us in. We adapted to the situation and made the best out of what

we had to deal with. Unfortunately, this trait we have has also been used against us numerous times throughout the history of America because it creates an entirely different market that flourishes in generating money and business.

The idea of dropping crack cocaine into the ghettos of America during the early 1980s was to destroy the black community. If you lived in these low-income areas during that time, either you sold it and lived off the income of selling crack or you or your family members or friends used it or died from it. This always benefited America. However it also motivated many of us to push hard to uplift ourselves and get out of the ghetto neighborhoods of America to have a better life and escape the effects of living around drugs.

Gentrification

Gentrification in America has always been a negative thing for blacks simply because it meant investors moving into black-owned neighborhoods and taking their homes and properties. With lack of education and energy to fight investors and other companies who bought you out, it is inevitable to be the victor in these cases. However, 90 percent of people who were pushed out of the projects and low-income areas were forced to live a better life by being either moved to the suburbs or provided housing through rentals and even purchase opportunities that they never would have experienced if it had not been for those project areas having been closed down or demolished for other development. The sad part to this is many of us were not in the position to purchase those areas ourselves and develop something uplifting and better for us. Yet we are slowly getting there in this day and time and learning that our dollars are more powerful than those that have always led this country.

What has happened in us as black people today is we truly learned from our oppression and we have learned to turn around and do something about it rather than allow abuse and mistreatment to continue to happen to us. Therefore now we too are slowly starting to invest and buy out parts of our own community and realize that there is value in our areas. We have adapted by making our homes better than we ever had, transitioning from poverty-stricken areas to middle-class living. Of course this does not speak for all black people in America, but as a whole, we have adapted to the change that is forced upon us.

What we must be very careful with though is allowing others to make a mockery or fool out of us during our transitioning. Reality

shows have become the stage for watching black people act a damn fool, showing that they are out of control with "new money" or what looks like money, thus positioning black people right back in a place to be disrespected and not taken seriously. The gifts and talents we have alone could pay our way into prosperity, but we often sell ourselves short for a TV camera to be in our face for very little money. We are better than this and have to recognize within ourselves as a people that we can channel our talents in directions to uplift our people instead of being degraded as America's entertainment. Through athletics, music, and acting, we are the entertainment for the world to enjoy. This isn't a bad thing, but America has made it bad by presenting a clear notion that this is all we are worth—entertaining and making money for big white moguls or corporations. The NFL has done an excellent job of showing us this. Yes, our talents and gifts make many of us prosperous and wealthy as individuals but have never done anything to bring financial wealth and power to us as a people. The money entertainers and athletes make in comparison to the corporations that signs them and controls them is like charity pennies.

Trends and the Dangers of Trends

Trends have proven to be more powerful than any of us care to admit or ever talk about. It negatively impacts all of us more than positively. Trends program the mind to visually see and accept dysfunctional acts as normal and okay. So once you open the door to one questionable trend, then that leads to worse trends and situations. So many trends have become normal until we have been conditioned to dysfunctional norms. Dysfunctional acts and ways of thinking become immune to people who consume it. They no longer realize that they have all become a part of abnormal and often sick behaviors and mindsets.

If every day for several years you see ten-year-old kid sawing his arm off, the gruesome act will eventually become a norm. However, the act of a child sawing his/her arm off is not normal at all. Yet a society that allows anything that is considered to be cool and acceptable to go on ends up poisoning the minds of all who live within that environment or world. Therefore many of the things we have become adapted to and feel that is okay is really more so us adapting to crazy things that have become the new norm.

One example out of hundreds is this—wearing of sagging pants was inspired by prison mentality and life. This evolved into a fashion idea that began as a trend in the hip-hop industry by rappers of the early 1990s. Now forty years later, what started as a hip-hop fashion trend to display the name brand of men's boxers has now evolved into downward display of mental illness by wearing pants below the buttocks, allowing the entire underwear and ass of a man to be seen. This act became a norm and evolved into worse than how it started. The origin of wearing sagging pants we know derived from early

years of prison life. However, different generations care less of its origin and participate in the trend no matter how dysfunctional and abnormal it actually is. This negative trend seems normal because we have witnessed it for forty years, so the human mind adapts to accepting it as not being a big deal. This is what dysfunctional and abnormal things eventually become—a normal act because the mind becomes conditioned to what it sees over and over again. So now dysfunction is no longer recognized as how crazy something might be.

America: The Biggest Gangster in the world

Legalized Scams throughout the Entire System of America

Taxes: The stress of the system of taxes. America the Pimp

You are taxed in America on any income you bring in. Then you are stressed about filing taxes at the end of each year, often having to pay more after paying taxes throughout the year, which is automatically taken out of your paycheck. Only in America do we have a manmade pimp system of taxing every item you purchase from property to bubblegum. Therefore, you really never own anything of value like property or land because once you have completed the payments on the actual cost of the property; you pay property tax to the government until you die or until whoever takes over the payments die. So is the property ever really yours? No.

Then you equip yourself with education, skill training/trades, and apply for a job. You get the job based on what your experience and years of training only to have a percentage taken out of your check by a government that had nothing to do with the hours you put in on the job, the experience you acquired to do the job, and the hard labor you perform to make the money. You work hard and even overtime, and the government takes a portion of your money that YOU worked hard to make, and you have absolutely no say so in the matter. Does this sound familiar? Yep, this is the same description of the traditional pimp and his hoes.

A prostitute cannot make a dime without the pimp getting his cut off the top, and the pimp decides how much his cut will be, and if you try to keep any of the money or not let the pimp know you made a certain amount of money, that pimp will beat the prostitute or lock her in the house for a while until she learns to be obedient with giving up the money SHE worked for. So like it or not folks, we American citizens ain't nothing but some old helpless whores.

Making money off the poor: Thrift stores

Have you ever seen a place that takes items that have been donated for the less fortunate and that organization turns around and sells those donated items to people in need? Thrift stores are filled with donated clothes and furniture with price tags still on them. We are supposed to help the poor by teaching, offering opportunities, building skills, and showing them resources, not put a price on the things they need just to live and function as human beings. This is the same as TAKING from them.

In all fairness, it would be more reasonable for these organizations to sell items to other organizations who are helping the poor or disabled rather than selling to the actual citizen who is less fortunate. If business has to be involved at all, why not give to the poor and sell to the organizations who are helping the poor? And we wonder why so many homeless Americans take on the mindset of being satisfied living under bridges, in woods, or on the sidewalks of city streets. Outside of circumstances that placed them there, many of them see the scam and the struggle and would rather owe no man anything to have their own piece of mind and not be robbed or swindled out of every penny they have. To be fair, it would make more sense if they had a method of separating working-class customers from poor customers with little to no income. Sell to the employed based on salary and give to the poor and low income. Yes, I know the prices are beyond cheap in thrift stores; however the concept is still selfish to sell clothes that are DONATED.

IMPACT OF AMERICA

Convenient fees

Being charged a convenient fee for credit card method of payment sounds normal because we've all been conditioned to it. America created the credit method and promotes the credit method, and then once millions of Americans buy into the credit system, they are charged additional fees for using a credit card method of payment. Gas may cost $2.25 if paid by cash. Using a credit card, that same gas would be $2.40. There are convenient fees as much as $50.00 in addition to the purchase of merchandise or service. What the hell is a convenient fee? I didn't ask anyone to create the credit card. America chose to create the credit card and then forced it on its citizens. So why give me something useful and then charge me for using the damn thing that you created for me to use? And why would you rob me of more money when I'm already giving you business?

Yes, I know partially it's because the merchant accounts are charging the business for offering credit option. So everyone is raping everyone. The business gets raped, and then the business rapes the citizen even more. Instead of charging the business one time for the business and service, they have to continue getting paid off the business' daily revenue. That sounds very much like the drug man who takes a cut of all the businesses operating where his drugs are being sold. So now you see who the master teacher is in legal and illegal business—greed + legalized system=scam.

Hospital parking

Have you ever thought about the cruelty in being charged to park at a hospital. Why would you charge people to park who are visiting the sick, dying, and shut in? Furthermore, the hospital is already making billions of dollars from the billing of every patients' insurance, so they rape the visitors and loved ones of the patients with parking prices. So it's not enough that the hospital is raping the patient's insurance, the greed motivates them to rape the families and friends who are visiting them as well. This is money being made off one person who is sick or dying. Imagine parking at the hospital

and your time runs out on the meter, and you come out and your car has been towed while visiting your mother who's dying from cancer. No matter how one tries to justify charging for hospital parking, it will never make sense. This is almost as bad as charging to park at a funeral home or cemetery.

Airport pimp

The unfortunate tragedy of September 11, 2001, was a huge opportunity for American airports to create a billion-dollar cash bucket. You go to the airport to fly to a destination, and any liquids of any kind are confiscated from your carry-on bags, and it's all blamed on the one incident of September 11. However as soon as you get through security to your gates, you are allowed to purchase the biggest bottle of beverage, water, perfume, or cologne of your choosing and step right on the plane with a hundred gallons of any purchased liquid. The streets call this pimp game, but America plays it better than anyone. Now all this is for safety purposes because of 9/11. This was mandated because it was said that anyone could make a bomb out of any form of liquids that passengers might have on board the plane. However those same safety concerns no longer exist once you are inside the gates before boarding your plane. Just another million-dollar cash cow.

Cell phone companies

They have learned how to monopolize and capture free airspace and sell it to any human being wanting to talk on a cell phone. Then they designed the phones to malfunction or have complications within two years. All phone chargers are designed to malfunction or have electrical shortages within six months to a year. You're lucky if a phone charger would last for more than three months. This of course keeps you purchasing phones and chargers constantly.

IMPACT OF AMERICA

Medical billing

Did you know that every hospital or medical facility follows billing codes that are based on the time you spend in the ER or the hospital? This means those long unnecessary hours you spend in the ER having vitals checked and waiting more hours just to be seen by the doctor and told nothing is wrong or actually treats you for something add up to thousands of dollars per person. A particular billing code is attached to the services the hospital is providing. Therefore if you only had a scratch on your knee or a sprained arm, you were billed for every lab test, every vital check, and blood drawn including the number of hours you spent there just to receive a Band-Aid or more serious treatment. Either way, your insurance will be billed for some thousands based on the time and other unnecessary services you really didn't need. A medical bill from the hospital to your insurance company for anything from a broken leg to the common flu or pneumonia is anywhere from $5,000.00 to $65,000.00. The dollar amounts go much higher, depending on the severity service. In other countries, you would be disappointed and amazed at the lower price contrast.

Commercial Driver's License (CDL)

Why is it that you MUST have a commercial driver's license (CDL) to drive a bus you purchased or to drive a bus or truck for any company, but you can rent the largest U-Haul or other commercial moving truck available with only a credit card and "normal class C" driver's license? It's all about the money.

Seat belt law

With the seat belt law, our country is very considerate to care about our safety. However, why is there money attached to an act that would only harm or kill you, not anyone else? In other words, if I chose to drive without protecting myself, that is not hurting anyone else but me. So now if I am caught not wearing a seat belt,

which is half the American drivers, I get a ticket costing anywhere from $15.00 to $50.00 to be paid to the city because I didn't want to protect myself. Yes, I'm aware that the purpose for the fine is to encourage more drivers to drive safely and save their lives. But when I look at the pattern of America and its cleaver ways of getting into everyone's pocket, it makes me question this act of so-called concern. Now you may think this is petty thinking, but conditioning of the mind will have you looking past numerous things as if it is normal. It's not normal; it's just we are conditioned to being manipulated and controlled. This is simply another cleaver way to get money out of the pockets of every day citizens.

I would certainly agree and understand a fine for not having children in car seats or seat belts. As adults, we have an obligation to assure the safety of children who cannot think responsibly for themselves.

Pharmaceutical

Here's a typical one. America creates some of the most powerful drugs known to man that can be purchased over the counter or by prescription only. These drugs' side effects cause numerous health issues and even death. However, street drugs are allowed into the country by the same country and are sold by black and brown people, which is totally against the laws. In other words, if America ain't in on the cut or their portion of the money made from the sales, it's illegal, although America's pharmaceutical industry is selling slower-killing drugs all over the country.

Crack cocaine entered the black ghettos of America in the early 1980s killing numerous women and children hooked on the drug along with violence that was attached to the drug. However, this was looked at as no problem in our government. From 2015 to 2020, the opiate epidemic got rave reviews and concern because thousands of white Americans were hooked on the pills and dying much like black and brown Americans did in the 1980s. So now there are substance abuse programs and campaigns popping up all over America to stop opiate drug abuse and other similar substance. FYI, I have a

friend who owns a pharmacy, and I am privy to his wholesale cost on medicines and prescription drugs. Trust me when I tell you we have been raped for many years when it came to the cost of medicine in America. That's all I'm going to say about that.

Voting: Requiring ID to vote

Why should anyone living in America need an ID to vote for how they feel should be in position to help create and run laws for the people? Again conditioning will make you miss this point completely. Do you realize an ID has absolutely nothing to do with a person voting? The only time an ID should be asked to be presented is if the person voting looks younger than eighteen years old. Other than that, anyone that comes to the polls with a first and last name should be allowed to vote. This is nothing but control and keeping the numerous elderly and mental health individuals out of the polls who may have an expired ID or no ID at all. Mail with your address and matching the name and address the polls have for you is all that should be required if there is a question about who you are. A snapshot of every voter can be done entering the polls to avoid any repeated attempts to vote.

Billions to trillions of dollars in the "treatment" of fatal diseases rather than in the cure of fatal diseases

For years, America has chosen what diseases to treat and which ones to provide the cure for based on the infectious epidemic. America provides a cure for diseases that one can live with. America provides only the treatment rather than the cure for diseases that are fatal and will eventually cause death. America provides the treatment for these diseases because it keeps individuals paying for the need to stay healthy. Paying for a treatment that is needed every day or every thirty days requires that millions of people who have this deadly disease pay for it through doctor visits and prescriptions for the rest of their lives. When you add up the number of people in America who have cancer, HIV, and other deadly diseases, you find the revenues in

the trillions of dollars made from medicines and researches that are in place for numerous years to come justifying the trillions of dollars made from only the treatment. A cure is a onetime payment that would end profits before it would even reach a billion dollars.

Insurance companies

You pay into an insurance company for life insurance for your entire life. You die and have to fight with the same insurance company you've paid thousands of dollars to your entire life to receive the policy amount that was guaranteed if the insured dies. Notice how easy it is to buy an insurance policy or buy into a plan that insurance companies are always selling. However, when it is time for the insured to cash in on money owed to them, there is often red tape involved. Problems that involve a deceased individual and family members who are documented to inherit funds often need legal representation for this transaction to happen smoothly and lawfully. Many individuals without legal representation are taken advantage of by insurance companies and are more than often never paid.

Mortgage program: "Reverse mortgage"

Cutting through the long fluffy details straight to the point, this program inspires elderly individuals from age seventy and older to refinance their home into a "reverse mortgage" program that allows the individual to live in the home with no mortgage. Well, what happens is once the individual dies, the house automatically goes to the bank. The bank of course in turn resells the house for another profit. The house was owned by the elderly person for a number of years and usually would have acquired a great amount of equity over the years. Therefore if the person continued paying the mortgage, either it could be taken over by a relative or loved one to complete the minimum years left on the loan or the house could be paid off by the mortgage company as part of the mortgage company's payoff program if the owner passes away. Reverse mortgage cancels out all of that by basically snatching the home as soon as the individual dies.

There's no passing the home down to family or allowing the profits from the sale of the home to go to any beneficiary. There's no equity left in the home because the program takes all equity left. Therefore the banks profit from the equity of the home and then owns the home after the elderly passes away and then sells the home for even another profit.

Bank scam

Keep in mind most rules and policies are created based off illegal situations that have occurred or safety and security issues that have been breached in the past. Therefore, the organization comes up with a method to protect these illegal acts from happening. However, they always create a rule that benefits them as well while protecting the client. When you look closely at the situation, you discover that the plan was really never to protect the client, but more so to generate more profits for the organization in the sneakiest way possible. This leads into the point.

In America, you can no longer deposit cash into anyone's account. They did this to cut down on so-called fraud, embezzlement, or putting money in one's account without their permission or knowledge. Now the reason all that is bull crap is because there are several measures that could be mandated that covers the concern. My solution is this—the bank could always require a valid ID and a picture taken of the person depositing funds right at the window as he/she is depositing. Instead of a solution as simple as just mentioned, the banks now require you to purchase a money order or cashier's check just to deposit the money into the person's account.

In other words, now you are required to give the bank money just for depositing money into a person's account. The bank makes anywhere from $6.00 to $10.00 from the person who is depositing money into the account of a member of that same bank. How low is it for the bank to basically take money from anyone for depositing money into a member's account? It's almost like they are jealous of their members having money deposited into their account and they

are going to make sure they get in on some of that money too. It's downright petty.

In addition to the deposit scam, banks in America made $34 billion in bank overdrafts in 2017. This means they took money from people and charged those who already had financial issues or no money. Coldhearted legalized scam.

How Conditioning Controls the System of America and the People

Conditioning is teaching and training the mind to think one way or in a particular way in order to control the outlook on various situations and issues of life. It is imparting ideals in the mind that force the carrier to mobilize in the way the person who is training to go. Conditioning is the most powerful concept known to man. This is the tool that makes the entire world operate. America has used this to their advantage to build, do business, and manipulate any system created. Conditioning is the same method used in schools, corporate America, associations, police departments, religious organizations and denominations, general businesses, etc. It is through the conditioning of the mind that controls the operations and the outcome of any program, organization, or group of people.

The true reason slavery lasted for hundreds of years was not at all due to shackles, chains, dungeons, or prison caves. Slavery lasted for hundreds of years because of one powerful tool, conditioning. The psychological bondage of African men and women kept slaves from ever rising up or overcoming the oppression and abuse. This method was passed on through hundreds of generations and still works very well within the black culture of people to this very day.

When an idea is taught and drilled into the minds of people through fear, abuse, and belief systems, it is very difficult to erase that conditioning because it has taken root and been beaten into them. This concept comes with effective factors that make the impact last through hundreds of generations.

First is consistency—the consistency of conditioning the mind that keeps it living and breeding through generation after generation. The same concepts of imparting a way of thinking for a selfish agenda is used to this very day in politics, churches, programs, and cults. Consistency assures a generation of defeat and an accomplished agenda.

Second is stripping of a culture and way of thinking to be replaced by a new culture that didn't belong to Africans nor was of any part of the African culture or lifestyle. Africans were force fed a new way of living, comprehending, and seeing beyond what they already knew and understood as themselves.

Third is the belief system. This includes the following: giving new religious ideals and stories to grasp and adopt as truth, equating the biblical God to the hierarchy of their slave master, comparing the white skin of Jesus and God as to being the same as the slave master, teaching a religion to Africans as the only truth according to them, and denouncing the African cultural beliefs as untruths. The most powerful concept known to man is the belief system. The belief system confuses the masses of not only America but also the world.

What many don't realize is that beliefs are completely different from truth. They are two totally different things. What one believes is what he/she has been taught to believe. Therefore, there is usually no evidence of its truth because it is a belief. The hidden root meaning for belief is "I don't know," which also means it is something that I hope and feel in my heart to be true. In all actuality, it is simply what you have been fed, taught, told, and sometimes forced to believe. This becomes your personal truth.

Beliefs make us feel very comfortable often because it is what we have heard our entire lives, passed on to us by our parents, grandparents, and great-grandparents. However, it still doesn't mean that what has been traditionally passed on is truth. It's simply the same belief that has been passed through generations after generations. People are passionate and aggressive about what they believe because it is all they have ever known and they usually have dared not to think outside of what they have been taught to believe. Therefore this belief

becomes a part of their heart, and they will fight and go to their graves believing something that has never been proven to be truth.

The difference with truth is that truth is usually uncomfortable. It is what it is whether a person likes it or not. It doesn't make you feel warm and fuzzy inside. It is transparent and stands alone 100 percent of the time with not much amen, or shouts, or agreements. It deals with reality and what cannot be questioned because the evidence is easily obtained.

As Christians, we believe Jesus died for our sins and he would come back one day to call those who followed the holy Book of Life home to heaven. Arabs believe that if they kill or take their own lives in the name of Allah, they will enter the gates of heaven and will receive ten virgin wives. I have never heard what rewards the women will get, but the men would receive ten virgin wives. Buddhism believes that life is full of suffering, suffering is caused by desire, and eliminating suffering is by eliminating desire by following the Eightfold Path or Middle Way of the ideals of Buddhism.

My point is there are numerous beliefs that are cherished and guarded with the lives of those who believe. However, no matter how powerful or enlightening the beliefs may be, they still don't equate to truth. For example, it is a common belief in America that man went to the moon in 1969. This is a belief because this is what was always told to us that happened. None of us witnessed man actually going to the moon and landing other than by TV. There is no evidence of man walking on the moon other than a televised occurrence that helps to support what we are to believe.

The following are questions to ask yourself about this belief:

1. Why hasn't man ever gone back to the moon since that day to commemorate our first landing on the moon?
2. Why haven't we gone back to the very place where Armstrong left the American flag?
3. Why hasn't any other country in this entire world gone to the moon since our claim?

4. Why has every trip to the moon since the one we were taught to believe always been only the robot or the space mobile and not another human being since Armstrong?
5. Have we even questioned the human capability of man surviving a trip to the moon?
6. Have we analyzed the distance and the amount of oxygen required and food to survive a trip to the moon and back for a human being?

These are far too many reasonable questions for this to be more than a belief. Debating this occurrence or if this occurrence ever happened is reasonable. However it is unreasonable to debate evidence-based proof. An example of truth is this—gravity exists. How do we know gravity exists? Because we live it and see it every single day of our lives. We have seen the contrast of numerous astronauts in space and how gravity pulls toward the earth once breaking through earth's atmosphere. Egyptian kings and queens truly existed. How do we know Egyptian kings and queens existed? Because artifacts, jewelry, tombs, and skeleton remains have been discovered for hundreds of years and can still be witnessed to this day as evidence.

Beliefs are personal and endearing and should never be disrespected or degraded but rather understood and put into perspective. "We hold on tighter to our beliefs than to the realities that we live in" (Dante Charles).

Conditioning works on the smartest to the dumbest human being. It is designed to distract the intelligent person to think he/she is outsmarting the creators of the conditioning or sets up a delusion to fool themselves to think they are on the same side with the conditioner. What the intelligent person doesn't realize is that they designed it to work on them in the exact way that an intelligent person thinks. So while the intellectual person thinks he/she is being so different from all the rest, part of a conditioning agenda is to help the main agenda of the ones who created the conditioning. This again brings in the divide that black Americans suffer from.

The not-so intelligent individual usually gets caught up in the part of the conditioning that captivates the masses by being follow-

ers, following whatever the leader or person portraying to be a leader says and never using their own mind. They follow the mind and ideals of others and are manipulated and dragged anywhere the conditioner wants to take them.

Once both divided sides wake up, they discover that they both have been used and end up right where they started from, while the conditioner stays on top and in power. The detrimental outcome of a nation of people who have been conditioned, is that a percentage remains trapped in that conditioning for the rest of their lives even until death. These conditioned minds are those who refuse to hear or open their eyes to any other possibilities or truths because their hearts have been rooted in the first beliefs or conditionings that were introduced to them or drilled into their minds. However, if there is ever a day when the two divided blacks come together, it will be the most powerful day the world has ever seen.

Religion

Like it or not, believe it or not, the concept of religion was solely used to control the African mind and their behaviors. The concept was aligned with the agenda to keep slaves in slavery and to keep them from ever rising up to think for themselves or to search for truth. Who would dare go against what they were taught to believe as God and the Son of God especially when a part of the teaching was that the master and his family were all a part of God and the slaves' obedience to the masters was the same as them being obedient to God. During this time, slaves had no concept of understanding the difference between religion and spirituality. All they knew were the stories taught to them and how it related to their daily lives as slaves.

What It Means to Truly Hear from God

Every day of our lives is evidence of us all living under passed-down traditions and misleading information. We heard our dear grandparents, great-grandparents, aunts, uncles, moms, and dads all tell stories about how they heard an actual voice from God. I truly respect and love the idea of hearing the voice of God in directing us to do positive things or encouraging us. However, it is past time that we put perspective and truth to this and not continue to spread what has proven to be inaccurate.

Hearing from God is indeed real! However, hearing the sound and tone of his voice when he tells you something raises concern and aligns with the state of one's mental health. The true way to know if God is talking to you is through confirmation. God speaking to you is having a number of things happening for you that are connected to other things that led you to accomplishing a positive goal or avoiding trouble, accidents, or death. When you know that God agrees with what you are doing, certain things in life related to your goal will line up in a pathway that leads you through a successful journey. It will all make perfect sense as it's unfolding and as you draw nearer to your goal. For example, you were fired from what you thought was a great job and had your car repossessed due to nonpayment. Just as you were fired from that job, an opportunity becomes available: someone with your skill set is needed to take the leading position, and the person must be able to start immediately. This job pays more, and it is more in your field than the job you lost. Oftentimes, when God is speaking to us, he will force you out of the situation you are in to

prepare you to receive a deserved blessing he has waiting for you. If you are busy being occupied with something that is not truly for you, then you miss out on God speaking to you or trying to direct you into what is truly for you.

Have you ever been so frustrated and unable to understand the things that happen to you in spite of all the good you are doing or have done in your life and for other people? We never understand it at the time, but it is one of the ways God is speaking to us to get us in the right place to receive a life-changing breakthrough or accomplishment. The problem we don't understand by spreading the inaccuracy of hearing God's voice is, when we allow ourselves to be wrapped up in traditional myths, we block ourselves from being able to identify the true voice of God. God is speaking to us more often than we realize, but we have been conditioned to listen for a voice and to wait for some prophet to tell us. God is speaking to you through signs and confirmations—clear messages that he is in agreement with what you are doing or not doing.

Here is another example: You miss a flight that you really needed to make in order to get to another state for an event at a certain time. You arrive to the event after it has ended, but the flight you were supposed to make crashed. You arriving late to the event also places you in the pathway of meeting an investor you've always hoped and dreamed of meeting just for the opportunity of sharing the details about your business. Now that most of the guests are gone, it leaves you and only a few people in the event mingling with the investor. You now have more time to interact with the investor than you ever would have gotten if it had been a scheduled meeting with him through a secretary or colleague. The scenario of the plane crash may be a little harsh, but in reality, God moves in his own way in our lives during critical situations such as this. It's his own way of communicating to us.

I could share a great number of examples of God speaking to us; however, one of the best ways and examples of all is one that only women can relate to. Women have the God-given innate ability to feel intuition. Most of the time, when there are no emotions involved, that intuition women have is 80 percent correct. This is

one of many gifts God created women with. It is a direct, deep inner feeling that communicates the answers to questions, doubts, curiosities, and troubles.

Hearing from God is indeed real. However, hearing from God in the way that man taught us to believe is just not true unless a diagnosis is attached to the voice or voices you're hearing. You can also hear clearly from God through good common sense. Common sense is an ability that cannot be taught. It is gifted to us through experiences and in learning to use good reasoning. Practice using your own mind, canceling out what doesn't make sense, and adding up all the components that logically bring you to a final conclusion or answer. If your house is flooding from a busted pipe, one of the things a person might do is call a plumber; however, the first thing one would do is immediately turn off the water under the sink or at the street to keep the water from flooding out the house and creating more damage to the home. This is that basic common sense that God gifted most of us with. The thing is you have to use the gift in order to benefit from it. Common sense is one of God's simple ways of talking to us.

Conspiracy Theories

Conspiracy theories are powerful methods of keeping the average person from using their own mind and own ability to research knowledge and information. The reason that conspiracies are so effective in convincing so many people is because, as human beings, we have been trained to love stories/tales. Since preschool, all of our minds have been filled with fascinating fairy tales, myths, and good stories. Stories are amusing and keep you on the edge of your seat. Stories allow the mind to imagine what is being told and thereby create our own visual film that keeps us expecting something, looking for something to happen, and attempting to make real life situations have the same outcomes as the stories we hold in our minds. Conspiracies place ideas in one's mind and make you feel empowered that you've discovered something that others aren't aware of. However, it does not show you that the ideas placed in your head were created by someone else or others to get you to thinking the way they are thinking or the way they want you to think. Conspiracies are the biggest distractions in the world because they are filled with fascinating ideas that captivate the mind, leaving you wanting to believe in what you've been convinced to be truth. In actuality, it's all just detailed propaganda and well-organized myths that lead to absolutely nothing. What so many people miss is that it is the believers of the conspiracy theories that bring them to life. The conspiracy only becomes true in the minds of those who believe in it and those who act on it.

The same time and effort that is put into real occurrences and events is the same time and effort put into building or producing a conspiracy, which is why they are so convincing. They are not quick little clipped tales but rather an idea that is created with splashes of

truths in order to make the conspiracy appear real. It is like a recipe: a little truth mixed with a sprinkle of dates and times that most conspiracy lovers will never research, familiar names or topics, and a seventy-pound bag of lies and myths to complete the false idea. Put it in a documentary and add a speaker who articulates the lies well, then you have a masterpiece that is fed to the masses of sheep thinkers who follow the idea to their grave. A strong conspiracy theory can be created in as little as a year to as long as five or more years, and it can last for a few years to a lifetime. Notice that no matter how crazy the conspiracy sounds, a great number of people believe in it because it has the same thriller components that a horror film has. The more it is filled with gossip traits that leave you wanting more and the more fearful, threatening, or frightening it is, the more we gravitate to the conspiracy.

Here are some well-known conspiracy theories that have come and gone to prove that most conspiracies are only distracting foolishness.

Extraterrestrial creatures and UFOs (unidentified flying objects). This myth lasted for centuries in America, and even after proven to be only a myth, some still believe it to this day.

The famous sightings of bigfoot, aka Sasquatch. This theory began in the '50s and lasted up to the late '90s. Even after this was proven to have been a prank that started in the late '50s, people chose to still believe in this eight-foot furry beast.

Bermuda Triangle, where airplanes, cruise ships, and other boats went missing if passed through a particular area of the ocean in Bermuda. We have not seen the remains of those airplanes or ships to this very day.

Malcolm X was killed by the FBI or CIA. What many don't realize is Malcolm was actually more of a threat when he followed the nation of Islam and demonstrated his ability to bring Black men to stand in protection of Black people. He was not about marching and begging white America to accept Black people. However, after Malcolm took the time to visit the city of Mecca, located in the country of Saudi Arabia, to educate himself and learn more about the true culture of Islam, he returned a more solemn and calm-spirited man, which separated him from the ideals of American Muslims. Malcolm was killed by his own Muslim brothers out of jealousy because of his popularity

and him waking up to truths that he was not knowledgeable of prior to visiting the city of Mecca. It wasn't the government who killed him. However, the government followed his every move and may have known that his fatal day was coming.

Y2K, the great glitch of America. This was when many people of America were made to believe that somehow, all electricity, gas, computer-operated vehicles, computers, and basically anything that worked would stop working at the strike of twelve o'clock midnight when leaving the year 1999 and entering year 2000. They believed no food or water would be accessible, that stores would be closed, and that banks would no longer operate to obtain money because nothing all across America would work, including the world. Millions of Americans went out and bought tubs of water; cleaned the shelves in the grocery stores; loaded up on cans of gas, guns, and ammunition; and prepared for the biggest disaster in the world, only to find out at 12:01 a.m. in the year 2000, they made American grocery stores and hardware stores millions of dollars for absolutely no reason at all. Again, this comes from a lack of education and proper research. This also showed the millions of people who really thought the world was only the age of the current year. There have been numerous conspiracies like this one where we all were supposed to die from poisoning or whatever, yet we are still here.

Donald Trump and a declaration of martial law for him to remain in office indefinitely and continue screwing up the government through his presidency and a lack of political leadership. Long story short, marshal law never happened, and Trump was kicked out of the White House.

COVID-19 and population control. So the vaccine that was injected into hundreds of millions of Americans to help fight the coronavirus is really a liquid chip that would control the mind and monitor the locations of all who took the shot. This is then connected to the 5G internet towers that have been placed in various cities and states to control the mind and turn everyone who took the vaccine into "zombies." Here's the biggest misunderstanding of the entire conspiracy. The CDC (Center for Disease Control) created a clever campaign to get more Americans to take community disasters and emergencies more seriously. This was also an effort to get people in the mode of

urgent preparedness in case of floods, storms, or environmental outbreaks or emergencies. They used the idea of a zombie takeover to grab the attention of many. Needless to say, the idea worked exactly the way the CDC hoped it would and has mobilized many people to get all the emergency items needed in case of various emergencies. Conspiracy writers took this much further and added the story about the vaccine and 5G. Sorry, conspiracy lovers, there's no zombie apocalypse coming, and the vaccine and 5G are not going to turn us all into the walking dead. Comprehension and understanding is the main purpose for reading. What many have done is they have read the CDC's preparedness page with their own fearful ideas in mind instead of reading the page as it is written. Keep note of the year this book is published, and keep in mind that the conspiracy was created around 2019/2020. Let us know if you see any vaccinated zombies walking around a few years or more from the publishing of this book.

Illuminati. Here's one of you conspiracy lovers' favorites! The famous Illuminati conspiracy started with the real story of a small group of men who started a secret society. This secret society began in 1776 and lasted only about nine years, ending in 1785. The original group was started to spark new ideas toward wealth with other so-called elites. The purpose and idea would also inspire voting power and abilities to impact the community in a favorable way with their ideas in mind. Adam Weishaupt was a German law professor is who founded the Illuminati group and educated members on his ideas. The way freemasons got involved with the Illuminati was through the small group of Illuminati members recruiting them to increase the Illuminati membership. The Illuminati would go to freemason lodges and recruit on a regular basis until the membership grew to larger numbers, which encouraged more who were interested to join as they saw the group increasing. The problem that came about is what comes about anytime you have more than one vision in a group or organization that is meant to have one leader and one vision. The group became divided due to the original members clashing with the freemason members who had their own ideas of what they wanted the group to represent. This is when evidence of man-made foolishness came into the doctrine of the Illuminati. Through chaos and

different ideas and opinions from the original purpose, the group crashed and no longer existed after 1785 when the Duke of Bavaria Karl Theodor banned all secret societies and implemented harsh punishments on anyone who joined these groups.

It was after the Illuminati and other secret societies were banned that the conspiracies began. The group had become so popular in spite of its disorganization and having been banned, and rumors stated that George Washington was one of the voices to speak out on the group starting back up as one of their members. Man-made stories and myths that started from 1786 and persist to this day about the Illuminati that never gained the power they really wanted. Many times, when real life stories don't end the way people hoped, they create their own story and pass it down through generations to take on wings and breathtaking occurrences that never happened. Today, religious groups have jumped on the bandwagon by producing documentaries that suggest a whole new unproven story involving the Illuminati. Now the conspiracy includes all celebrities worshiping the devil, human sacrifices, and desperate measures to gain more fame and money. If you allow anyone to program your mind to think that celebrities have their closest loved ones and blood relatives brutally killed or sacrificed in planned plane and helicopter crashes, you are the ones who give life to these conspiracies. Many of the stories of the Illuminati human sacrifices don't make the least bit of sense being that individuals who were killed; many of the celebrities related to them were already at the top of their careers and didn't need any additional money or fame. The stories are foolish and designed for soft minds that are easily fascinated by manipulating stories identical to movie scripts, mysteries, and horror. When you look at the actual reports of the deaths of people who lost their lives, you find the true answers had absolutely nothing to do with foul play or conspiracy.

Think about the purpose behind conspiracy theories that go this far to deposit fear into the minds and hearts of all those who believe and follow these myths. Why go to these depths to convince a population of people of an Illuminati conspiracy? What do they gain by telling the world that all celebrities are evil and of the devil? The current conspiracy speaks of famous musical artist Beyoncé and

rapper and philanthropist Jay Z being leading devil worshipers led by the Illuminati. Many believe this with only the fabricated production of the documentary, but the same people don't take the time to research the billions of dollars this couple has put into Black communities, schools, homes, and hospitals and their efforts toward ending diseases among children in other countries. They do godly work while being criticized and judged by people who are convinced by a group of people's documentary created for their own hidden motives. Why is it so easy to believe conspiracy theories versus the truth that is just as easily accessible as the conspiracies and myths?

In the new Illuminati, the so-called sign of the devil is seen being represented by numerous celebrities in the documentary. The reason I laugh at this is because, in my mind, who created the symbolic sign of the devil? They drew the idea in the viewer's head as they gave you something to equate the shape of the symbol to, and they matched it up with a hand position that many are filmed holding randomly in video clips and pictures. I'm no videographer, but many in the profession agree with me on this point I'm about to share. If I were to videotape or photograph you in hundreds of random pictures of you just being yourself, I guarantee I can get at least five pictures of you holding your hands together in the shape of what they created to be the sign of the devil. It is inevitable to not place your hands together at some point during conversations, deep thought, posing for pictures, etc…

I say to you, readers, that it is plain old distracting foolishness to take your attention off things that really matter in life and in this society. Having the opportunity to talk to several celebrities about this particular conspiracy did not surprise me at all in their responses. Everyone I spoke with responded with either laughter or an expression of "Ahh, man, give me a break" before I could even finish the question. We have mass shootings done by average citizens, serial rapist and killers, and sex trafficking organizations all at the hands of average citizens; but for some reason, the plot is to make us all think that celebrities are all devil worshipers. Stories like these are a great opportunity for you to use your own brain to think, research, and not allow other people's ideas to control your way of thinking. Yes, we have celebrities who make poor decisions and who are not kind in their behavior or way of

thinking. However, they are no different from the average citizen other than the fame. It is not fair to group all celebrities into one basket that has been created by other judgmental people.

The last thing you must keep in mind is that writers are absolutely brilliant in drawing ideas that captivate the mind and imagination. Misinformed documentaries are written story lines created by the same talent that writes movies, television shows, and seasonal sequels. Therefore, the entire purpose is to convince you of what they are showing you or telling you. It's supposed to be convincing and fascinating. Nevertheless, all of us have been blessed with our own individual mind, which has the capability of seeing through all propaganda, myths, fairy tales, and lies. However, you must be willing to utilize your mind in order to benefit from its power. You can't be a lazy thinker or a person who simply chooses not to use their mind at all and continue to allow everyone else to use it instead of yourself. This is how conspiracies and century-old myths succeed in convincing you of whatever they wish. A mind that is locked with wisdom, knowledge, or even the inquisitive thirst for knowledge is protected from trashy information. My encouragement to all who read my content is to practice using your own brain and feed your curiosities to search for truth and knowledge.

Forgiveness

This is an old traditional belief taught to us through religion and the Holy Bible. I respect its purpose and the foundation that this ideal stands on. However, I do not agree with the level of extremity it has been taught to us carry out. Its true meaning was manipulated and fed to us for the benefit of European slave ownership and the operation of maintaining slaves.

Forgiving my enemy or those who come against me is one thing and even forgiving someone who has wronged me in some way. I can understand the logic behind eventually forgiving that person to move on within myself. A critical example of this level of dysfunction is like a victim falling in love with a person who kidnaps you, rapes you repeatedly, and prevents you from ever seeing your family again. Pimps and sex-trafficking pirates are known for abductions and raping the victims. Imagine your daughter falling in love with these abusers/molesters, and once they have been caught, you are asked to forgive them for kidnapping, raping your daughter, and addicting them to drugs. Without using a conditioned religious mind, what real significance or sense would it make to forgive this beast of a person? The power of conditioning makes us feel that this is the appropriate godly thing to do. However, there are many supporting scriptures, as well as neurological and psychological research, that shows that this is an abnormal way of thinking. For me to accept the idea of forgiving that person for all these things because it will somehow free me spiritually and emotionally to get past the hurt and move on with my life is definitely a trained mentality.

For me to hug and embrace the person who murdered my mother, father, sister, or brother is one of the most powerful con-

ditionings taught through the same abusive practices and teachings of slavery. This is the same abusive conditioning of an abuser and the victim who is abused by this person over a long period of time. This dysfunctional mindset is the same as falling in love with a person who abducts you, rapes you repeatedly, and keeps you from ever seeing your family again. Imbalanced mental conformity is what this is. This is the same level of forgiveness rooted from the African who learned to embrace their master no matter what the master did to the African or his family. How dysfunctional it was to turn the other cheek, remaining meek and humble, regardless of the slave master having raped the male slave's wife and daughter. To forgive this was nothing more than teaching insanity. I am to give it to God and continue loving the master no matter what.

This misunderstanding of forgiveness has caused the African American to be the most abused and manipulated people in America. A major part of the trauma that continues to happen to black people in America is because of the ideals we embrace about forgiveness. This is why it is so easy for us to continue being abused after hundreds of years. It is in the system of America that has controlled our behaviors and way of thinking—to do absolutely nothing no matter what is done to us as a people. We were taught to do nothing then but pray to the God they taught us to pray to and to expect change that never comes until a percentage of us stood up and did more than what we were taught to do in order to gain the same respect that all other walks of life receive.

Imagine being abused by the slave master and others who looked down on you and mistreated you and then relying on that same abuser to feed you, begging and praying to that same abuser to not kill you or your family, and then praying for God to forgive that abuser for abusing you. The same man who raped your wife in front of you and had his way with your daughters and wife anytime he felt like a horny animal, you had to rely on him for supplies and rations for your family to survive. Ancestors had to pray and beg the same abuser to forgive them for being the victim of the abuse. Do you see how dysfunctional and psychotic this conditioning is? This is what became of black people over generations of years in this country

through a flawed teaching of what forgiveness really meant. This is a part of what we went through and continue to live through to this day.

What so many Africans then and African Americans now never understood was the change and end of slavery never came because we stayed within the system they designed for us to recycle the same nonresults. We were given an idea to pray to and believe in, and we turned the cheek and fell on our knees throughout multiple generations, never rising out of slavery or the mentality. It is not a bad thing that we learned about God and the Holy Bible. What was negatively impactful was we were never taught the effective way to move God and his power on our behalf.

We were forbidden from learning the true method of moving God because that would mean we would learn to put action with the Word of God. What to do after getting off our knees was what was left out from the teachings. We were never taught that prayer alone would never move us out of oppression. We didn't know that we would have to put action and the wisdom God gave us along with the prayers in order to move out of the oppression. By the time bold and ambitious slaves started rising up, a large percentage of African slaves were already rooted in the controlled system, shackled by their minds. Harriet Tubman and many others like her understood that action must go along with the Word of God in order to elevate African people out of slavery.

Language Barriers

An effective weapon used against Africans was taking them out of their own land away from their cultural language. Africans had to rely on whatever Europeans taught them as being truth for survival within a European system. Through adaptation, Africans eventually learned to speak in codes to each other by using their own language and slangs in secrecy. Africans had to rely on whatever the European told him or taught him as being truth for survival.

Divide and Conquer

A major concept used to divide and conquer was splitting up the African race during slavery. Europeans would impregnate African women to create a lighter-complexion slave to work in the plantation house. This division of having lighter slaves working in the house and darker slaves working in the fields created an envious divide among the slaves. The misleading perception was that working in the house was considered better living as a slave and not as much hard work as the field slave. This created hatred within the same race of people, not realizing that both the house slave and the field slave were both still slaves and were both being treated with disrespect and like animals. The same concepts of divide were done for the young and old and even pitting male against female by giving the woman the freedom to negotiate household business deals with the master instead of the male. This was another way of making the African male feel less than a man.

The woman had to ask the master for foods and other favors and often had to sleep with the master in order to get things done for her household. This brought about division in the African home between the husband and wife. Male slave was not respected or looked at as a man by the master, so he often felt the need to remind his wife who the man was by adopting abusive methods from the European to have a piece of respect in his home. The interaction between the female slave and the master often empowered the female to feel independent and not needing her African husband. Division among African slaves damaged and traumatized blacks for hundreds of generations.

Understanding More to the Root of Slavery and Its Impact

When we were finally so-called free, the term free slave was mentioned a lot. However, free slaves were never really free. Although the goal in mind for most slaves of the South was to escape or become free and move to the north. The injustice and cruel laws existed up north as well. The so-called free slaves still were not allowed the same privileges as other white Americans and were often threatened to be beaten or lynched for no reason. Just because it was eventually written in ink after the Civil War did not mean the mistreatment and abuse of slavery ended. It did not end.

Slaves who remained in the South where many grew up became attached to the South. They feared what the north may bring along with the freedom, and quite honestly many slaves who remained in the South were so conditioned to believe that it wasn't that bad and they would stay to be close to their former master who used and abused them all their lives. This was the shackling of the mind that held so many slaves in bondage even after slavery ended.

One of the main sources of wealth that came to some of the more cleaver slaves was a process called scrapping. Considering the years that slaves worked as sharecroppers picking and collecting cotton, no one understood the process of cropping corn, tobacco, sugar canes, or cotton better than the Negro slave. Some slaves generated wealth, passing it on to their next generations by the method of scrapping in the cotton fields. Scrapping was a method when slaves would go back to the cotton fields late at night, after all cotton had

been inspected, weighed, and collected by the plantation owners, to collect cotton leftover.

There was always scraps of cotton left throughout the entire cotton field after full bales of cotton had been collected. The cotton would be at the root of the cotton stems and on the ground. They would accumulate large portions of this leftover cotton until it weighed a worthy dollar amount, and then they would sell the cotton underground to other free black slave land owners or other desperate white land owners needing the cotton. These slaves eventually would become wealthy and pass on the wealth to future black families. This is also one of the sources where some blacks of black wall street inherited their money.

Understanding the State of Mind of Black People as It Relates to Racism

What Americans do not understand about African Americans is their lifelong frustration of oppression of black people. It is beyond commendable and highly intelligent of those white Americans who truly have an idea and understanding of how blacks have been impacted in this country and around the world due to the disgraceful history of America. The biggest misconception of black people is that somehow blacks are racist or prejudice. This is the biggest fallacy ever told about black people and still holds as the most foolish interpretation that exists today.

For hundreds of years, white America taught the world to fear black people and portrayed us as dangerous savages from television and books from the 1950s to the present. Prior to then, from slavery to the civil rights era to present, the same narrative has been pushed. The characteristics of a people always exceed that group of people by a history of behaviors. This is how people can tell what race of people committed certain crimes based on the type of murder it was combined with historical characteristics. For example, white men have been instrumental in having the most mass killings in America.

According to Statista Research Department, between 1982 and 2020, there have been 118 mass shootings. White men committed sixty-five of those mass shootings out of 118 recorded shootings between these years. This does not include the bombings done to black churches, buses, and homes dating back from the 1960s to

the present and still does not include the bombings to churches and homes done to black families and churches in the late 1800s into the ending of slavery on up into the nineteenth century.

The following is a list of mass shooting incidents between 1982 and February 2020 (Statista Research Department, August 10, 2020) broken down by race:

- White shooters: 65
- Black shooters: 21
- Latino shooters: 10
- Asian shooters: 8
- Other nationality: 6
- Other nationality: 5
- Native American: 3

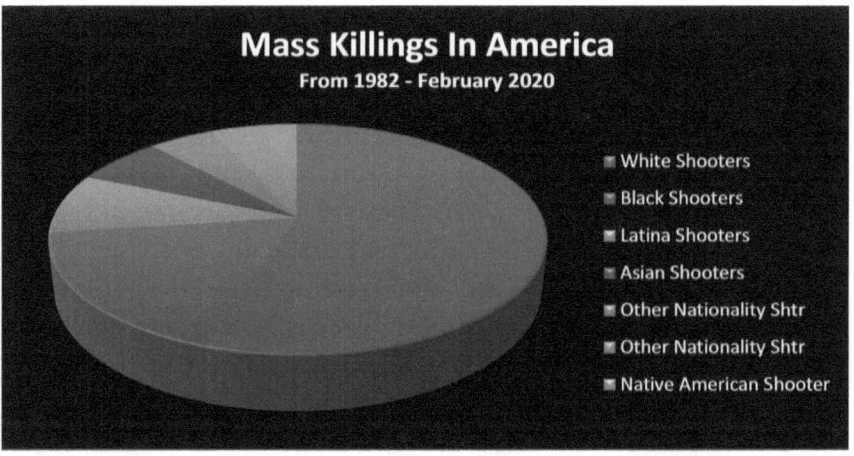

So how does this relate to the racial mindset of black people in America and why it appears that black people are racist?

The historic characteristics is to make the point that the misconception of black people taught to the world has always been an outright lie. Although we are not free from our flaws and homicides, we do not carry the characteristics of being savages. The European has proven through unbiased dated evidence that the hate within

that group of people are the ones who deserve that title that man should be fearful of. It has never been black people.

Black people have held on to anger and frustration because we have never had the time or chance to properly recover or recuperate from all the trauma that has been done to us for years. And worst of all, we still suffer through the same traumatic events that continue to be done to us today. So not only do we have to remember and educate others on the traumatic history, but also we have to find ways of dealing with the same killing, abuse, and manipulation that continue to happen to us; and on top of that, we have to fight against other blacks who refuse to break free from the mental shackles that our ancestors wore during slavery. I ask my white friends to imagine them and their people going through a life of relentless pain and abuse and how would they would handle this level of lifetime trauma.

When we as black people speak on racism and social injustice, it does not mean we are racist. It means we are reacting like any human being with a sane mind about what continues to happen to us as a people. The psychotic thing about those who don't care to understand is they stab a person in the chest over and over again and they get upset when that person starts screaming and yelling at them to stop stabbing him in his chest. They get angry because in spite of all the stab wombs to his chest and back, somehow this same victim manages to get education, jobs, nice car, and homes that they have. No matter what has been done to this black person, he just won't die, but seems to get stronger and obtain even more than he had before while bleeding from his chest and back from all the stabbing America has done to him and continues to do to him.

When we look at this closer with more perspective, who are the true dangerous savages of America? Adding to this point, we must ask the question, who has easier access to bombs and guns in America? Blacks have never had easy access to this level of artillery. Always keep in mind that many black people who you call racist have a diverse group of family and friends who all understand the truth about racial and social mindset of black people. We laugh and talk about the misconceptions and misunderstanding that so many white

Americans have on this issue. Education and truth always triumph over ignorance and lies.

Outside of the mass killings point, black people have been running for their lives since slavery. Today, in 2020, when we are pulled over by white police officers, we would pray the entire time that we will make it from the stop without being beaten or killed by unstable white police officers. Here is more evidence of present oppression toward black and brown people—there has been sixteen unarmed black Americans killed in one year, between 2014 and 2015. A total of twenty-five unarmed black citizens were killed by police in 2019 alone. The saddest reality of all is the stats that would reveal accurately the alarming number of killings of unarmed black people over the last thirty years is not found due to police departments and Department of Justice (DOJ) underreporting fatal incidents involving police and unarmed black Americans.

According to Laura Santhanam (pbs.org, August 9, 2019) and based on the findings of author and an assistant professor in the School of Criminal Justice at Rutgers University Frank Edwards, the DOJ stopped collecting data ten years prior from this 2019 report that related to deaths by police violence. The DOJ stopped collecting data due to the alarming numbers of killings and felt that the numbers were unreliable coming from crowd-sourced data methods. They felt that the reporting of the cases was voluntary, and there was no incentive for the police departments to submit the information to the federal government. This is where many organizations began using other methods of collecting data and relied on crowd-sourced methods through media outlets and statistic programs to help fact-check collected data.

Relationships of Men and Women in America (American Conditioning)

Unbeknown to many people, America has destroyed the soulful bonded purpose of relationships. The sad reality about dysfunction is when you live in dysfunction, you have no idea that you are living and operating in ways that are nonproductive to a relationship. The dysfunction becomes normal in the minds of all who follow the dysfunctional behavior and the cycle continues for generations. Evidence of America having lost the true meaning of life and relationships has always been in the divorce numbers.

We have strayed from love and purpose and dropped to status, benefit, and pleasing the onlookers instead of pleasing each other who are in the relationship. We have become so distracted by the ways of society and what America dictates to us what we should have or who we should be with. We are consumed with all unrelated things to do with a successful relationship and make the terrible mistake of focusing on things that only hurt and destroy relationships. One of the biggest factors to failed relationships as a whole in America is the stresses of living in America and feeling the need to live up to the expectations of America instead of to each other. When you focus on that one person and zone out everything and everyone that do not contribute to your relationship, you will find all the treasures in that person you're with that have always been there, but you've been distracted by everything surrounding your relationship, which are brought on by society.

Did you know that it doesn't matter whether that woman or man has a well-paying job or fancy career? A well-paying job or fancy career has nothing at all to do with what makes a relationship meaningful or long-lasting. We have been taught that this matters, so we see it no other way. And because of this ideal, we tend to make it a qualification or standard in choosing our mates. So what happens is half a population of people go through life unhappy, splitting up from one person to another because we are trained to look for these society-driven material things that have nothing to do with love and happiness.

Two individuals who see eye to eye and truly have each other's best interest at heart will support the other person in becoming the best he/she can be. If that means helping them prepare and obtain a better job, then that's what happens. If it means they both are happy with the jobs the way they are, with one making much less than the other and still working together to achieve what they want, then leave what works for you and that individual alone. We mess up when we try to keep up with what society says we should do. Sometimes the standards we follow are not our own.

They are just traditional standards passed down to each generation because they sound good and they are aligned with what society said was proper; however you still end up single and entering into your fifth, sixth, seventh, or tenth relationship carrying the same traditional standards that didn't work in the last ten relationships you have been in. Bills, responsibilities, and the cost of living will always be present in the lives of us living on earth. So why allow true happiness with someone you are really feeling to be sacrificed because you always envisioned having a man or woman who made six or seven figures? What kind of sense does that make when you really think about it without the conditioned blinders on?

What if the most beautiful woman you have ever encountered in your life, meaning total package of inner beauty and outer beauty, just happened to be a shift supervisor at the local McDonald's fast food? You are an executive in corporate America. What are you going to do? Leave this beautiful available woman to be misled by some other unfit person who doesn't see all the qualities that you see in her?

Throw away an opportunity to have exactly what you have always wanted in a woman just because she works at McDonald's? What about the fact that she comes from good upbringing and her mother or grandmother had passed down wholesome skills of being a phenomenal cook with nurturing mindset and positive attitude and is loving and caring and has a beautiful and fun personality and is a respecter of faith and godliness? Would you just throw all that away because this woman works at McDonald's?

So ask yourself where the last person, who you broke up with and wasted months to years of your life with, worked. If they worked a job better than McDonald's, then you should see my point. Ladies, are you going to judge a man because of where he works and miss out on who he is inside and the type of man he represents? Why gamble your happiness and time you have in the living by passing up a man who treats you with the respect your grandmother always told you to look for in a man? Why pass up a man that makes you feel the way you have always dreamed of feeling based on his job being at McDonald's or as a sanitation worker? Do you not realize that if you both are really into each other, you might be the only one to inspire him to elevate or reach for another job that he may be good at? My point is the job, money, and materials have nothing to do with the connection between the one that is right and suitable for your soul.

I remember my single days. I would pull up to a red light in my nice car, and an attractive woman might pull up next to me at the red light in her fancy car. Sometimes if the woman was driving something a little better than mine, she would be wrapped up into that mindset instead of focusing on the bigger opportunity. They would take off fast from the light when the light turned green to basically give the message, "I'm driving something better than your car, so I don't need you or you aren't driving nothing fancy enough for me." This would let me know right away that, yes, she was very attractive, but I wouldn't be interested in because of her mindset. And those few examples of women always missed out on the fact that I was driving my car home to a garage attached to a nice home with another car in the garage. Again, my point is the conditioning causes us to miss

out on life-changing experiences with mates that could be lifelong relationships/marriages.

The truth is we were not always this way in America. During earlier years, especially in small towns and cities, the wholesome upbringing of men and women flowed on through our relationships. This was before all the distractions came into play. So relationships were healthier and lasted longer on into marriages. Over time, American society destroyed the concept and our way of thinking as it relates to the purpose of life and relationships.

Please don't shoot the messenger, but I must share some discomforting truth. There are a vast number of men who travel to foreign countries to find love, not because the women are better in other countries, but because both men and women in America are tired of competing with unrealistic expectations set up by American society.

According to numerous opinions of men, they tend to find women who are simply focused on love and family. Women who are focused on love and family are usually attentive to the relationship, family oriented, and are often very nurturing to the relationship and their man. These women are not caught up into competing with society's game of stressors and outdoing the next person. Give them a happy home and a thriving relationship/marriage, and they are beyond satisfied. Mind you, the majority of these countries are poor countries with poor women. And all these women have to offer is a wealth of nurturing love, companionship, and stress-free attentiveness to their mate—no six- or seven-figure salary or careers, no fancy cars, no expensive lavish lifestyle, but just a true understanding of what love and happiness are supposed to look and feel like.

None of this means that there are no American women who understand this or offer this. There are plenty, and I'm proud to have one myself. However, as a nation, we have been damaged by the pressures and superficial standards of American society. I know a lovely couple who lived in America, and both had wonderful careers. They both decided to let go of American ideals. So they both left their jobs and packed up and moved to one of the many beautiful Caribbean islands. They bought a small house only walking distance from the beach and living and loving the wholesome culture to this day. This

move added to their marriage and left all the stresses of a relationship behind in America. They learned that the focus should be solely on the two of them and all positive components that add to their union.

The other important fact that women of America need to understand is that it is not that there aren't good women in America. That has never been true. That is the biggest fallacy that could ever be said. There are phenomenal women and black women in America. The problem is they are being missed by men who are worthy of finding them. My advice to good women has always been not to hide from the type of men you desire to have and not limit yourself to thinking that your mate is in your same city or state or neighborhood. That type of mindset alone will keep you single until you're eighty years old.

Also you must get rid of this old religious thinking that the man God has for you will find you. No, he won't find you if you're sitting in the house waiting on some magical way for the man of your dreams to find you. You will die alone with that same mindset. I believe that good women have to put themselves in the pathway of the type of men they really want. This does not mean coming out of your role of a young lady by chasing a man or looking for him. This is not a desperate measure at all. It is more of being realistic and stepping outside of all the fairy tales we have been taught by waiting on a good man or good woman to find us.

Let me share something that is real, ladies. You can sit your lovely self in the house and wait for a good man to land in your lap if you want to. But I guarantee you will be waiting until old age. No, you have to adorn yourself and get out of that house or out of your normal surroundings and way of being. Attend events that will have the type of men you're looking for. Visit churches that are building strong men and teaching them to be responsible gentlemen that fit your desires. Leave your side of town and go to certain parts of the city to do your shopping that has the caliber of man you're hoping for. Try online dating. Yes, that's right. I said it. Try online dating, which is also categorized by social class, characteristics, etc. Here's the positive thing about online dating many people miss. By meeting someone online, it gives you the opportunity to really get to know

the person before getting into the physical aspect. Online dating is more effective today than when it first started many years ago. Today you not only have pictures to share but also can speak to the person in real live video, so this way no one is surprised or pretends to be Denzel Washington when he's really Oscar the Grouch.

Online dating forces conversation and a peek into the person's way of thinking, personality, and characteristics. You can criticize these processes all you want, but I can show you numerous women who put themselves in the pathway of the man they wanted and are now married or in love with that man. We have to break away from a lot of the traditions we have been taught that ultimately resulted in us not getting what we wanted. If you feel that staying in your bubble and waiting on God to send your man or woman is what you are supposed to do, then you are welcome to follow tradition. But just remember that doing the same thing you've always done and expecting a different result is not only insanity but also delusional. For those who wish to debate this mindset I've shared, it's fine too. But please make sure you're not single and still looking for your mate while debating the mindset I've suggested to find your mate. Nine times out of ten, you've tried your way all of your life. Try something new and effective.

Now once you have put yourself in the way of finding the special man that you've wished or prayed for, you can't be hung up on all kinds of irrelevant rituals and standards that will keep you from receiving that man now that he's in your face. Be careful not to turn off that special person once you have found them or they have found you. Do not allow yourself to block your own blessings. Oftentimes our mixed-up beliefs and way of thinking block us from a blessing that would be perfect for us. Know when to close your mouth and shut your mind off from your picky ridiculous standards. Do not misinterpret what I'm saying to you. Having standards are good! But having unrealistic standards is a waste of your time and the person's time and is often evidence of fooling yourself in believing that you are such a perfect flawless person who deserves a perfect flawless person. I'm telling you right here and now that's more foolishness.

Did you know that different cities, states, and countries carry a different mindset and characteristics of men and women? There are things about you as a person that may not appeal to men or women in your own city of Atlanta as much as your qualities may appeal to someone in Chicago or Nevada. The attention you receive in Alabama might double in New York because those Southern traits and characteristics might stand out more in New York because they aren't used to seeing those Southern traits. You might be a woman who doesn't get a lot of attention in Detroit, Michigan, but for some reason, when you go to Jamaica, the men adore you and think you are the most beautiful woman they have ever seen. Of course these particular cities I've mentioned are only examples, but it actually happens just like this because every city, state, and country have their own cultural characteristics in the mindset and behaviors of the people. In my previous years as a single man, I found that I was more appealing to women located in different states, not that there wasn't many women who liked what I had to offer in my own state, but there was a very noticeable difference in how I appealed to women in different places. There may be things about you that are not commonly seen in another city and state from which you live. This even includes looks, complexions, and dress styles.

There are all types of factors that lead to finding a mate outside of your area code. When you look closely at this, it's really not a bad idea, especially if you haven't had any success in good relationships from men or women located in your own backyard. I've met ladies who were in their fifties talking about they don't date outside of their city and refuse to do any long-distance relationships. Yet while they are making that foolish statement, they are speaking while in a single status and at an age that is slowly climbing into older age. Why limit your chances of happiness especially when you currently live in a single status at fiftyish and have yet to find love? Close-mindedness results in limited exposure and slim chances of having what you want. Here's a final example to support this idea. Outside of my own successful experience of having found love outside of my home area, my parents lived in two different states. Dad was in New York, and Mom was in Aniston, Alabama. Long story short, they met and were

married for fifty years. Just thought I'd drop that on you to ponder over.

The constant trendy distractions of making money and showing everyone who's looking that you're all about "making your coins," "getting to the moneybags," etc., are all signs of distraction and conditioning. The conditioning is all around us through music, movies, and lyrics. We follow those lyrics and create a trend out of unhealthy conditioning. Conditioning and unhealthy American trends lead to the typical mentality of women bragging about their financial success and not needing a man for anything but sex, and possibly, not even that. The same mentality encouraging men of bragging or lying about being successful and measuring their value off material things and what they say they own, or what they stress themselves to obtain to impress the woman. The conditioning of men goes as far as putting fancy cars, jewelry, or clothes out front as bait to catch socially brainwashed women who are attracted to the materials and not the person behind all the bling and glitter. And we wonder why we have so many failed relationships back to back. If you are offended by these truths, then that's your evidence of being a victim of American conditioning of relationships. You're caught up and can't face those truths.

Here again is the damaging impact. This same conditioning spreads to other parts of the world because America is the country that has always been on display for the world to pattern after. So these same flaws exist in many other countries because America sets the popularity stage for the world. Just look around as you travel to other countries, and it's very clear to see.

You wake up one day and realize that all this superficial bullshit has absolutely nothing to do with love and a nurturing relationship. Having and sharing nice things should not be a part of impressing those outside of the relationship. Having and sharing nice things should represent just one way of showing that person that you appreciate and love them. It is the dedication of love and sincere treatment that should support the sharing of money and fancy things, not to please the onlookers of society. This mindset has made all of us in America a slave to society's methods and ideals, leaving the essence

of love and longevity in relationships and marriage to be lost and buried. The biggest blessing in life is captured by those who escape all the distractions and find the treasure of love and happiness.

Here's a final hint, ladies, of how to obtain the "stuff." My wife was given the most beautiful diamond ring she ever had in her life and frankly the most beautiful diamond ring I have ever given. The reason she received this particular ring is simply because her mind and heart were always into me and the relationship. She could care less about a ring and never mentioned one word of a ring during our time of dating. She didn't know anything about clarity, size of diamond, or the cut. She only wanted to spend her life with me and enjoy doing all the things that come with a loving relationship. She poured into my life as I poured into hers. She thought of me when she should have been thinking of herself. All these things and more is how she acquired the ring that most women yearn for.

If you sincerely get into your man and forget about all the other distractions America has taught you to focus on, you will see more of the rewards from being sincere and true. A man that can see that you are truly into him and the relationship will do everything in his power to bless you with the best that he can afford. And even if that best is only a zirconia or other gem of lesser monetary value, the fact that it came from his heart and was the best of his ability makes that ring far more valuable than any high-priced ring that existed. Nothing in the world can compare to sentimental value. Cherish your man and he will cherish you!

In my years as a counselor, I have seen well-established men and some men who were not well-established leave drop-dead gorgeous women with no kids for a woman with two or three kids. The women they left may have had a great career, decent amount of money in the bank, and turned heads every time she stepped foot out of the door. That same woman did not have nurturing traits and would tend to put a lot of stress on that man. So as crazy as it sounds for that man leaving the drop-dead gorgeous woman with a great career and other things going for herself, he left her for a nurturing woman. He left her for a woman with children, a woman who had patience, and a woman who didn't stress him out or leave the pres-

sures on him of having to meet standards that really didn't amount to anything relative to a thriving relationship. He actually gained more from being with the woman that society ignores and frowns upon. He came home to a woman with kids, but he wasn't stressed out. He had a hot meal waiting on him when he arrived home. Due to that woman being more grounded, he sometimes met her at the door with movie tickets for the weekend or tickets to a concert or dinner reservations to eat out.

I ask that the reader please remain in a higher level of thinking as you read these ideas, examples, and real-life scenarios. When I speak on these issues of examples, I am never talking about every single person in America or the world. Therefore I am relying on you, intelligent individuals, to realize that yes, there are millions of high-career women who also have nurturing traits and know how to properly love their man and cultivate the relationship. I am speaking on the flaws and conditioning that America has placed on a large percentage of all of us men and women as it relates to relationships.

So, ladies, who have phenomenal careers and a lot of well-deserved achievements, please do not feel offended. You have no reason to feel offended unless you fit into the scenario of the woman who have priorities mixed up between nurturing the relationship and idolizing her career. If you feel offended, then it's worth doing a self-evaluation no matter how frustrating it may feel to deal with the truth.

It is very possible for a woman to have a great career and still deposit into the relationship those wholesome nurturing traits that every relationship needs. There are a great number of high-achieving women who do an amazing job of loving their man, nurturing the relationship, and giving him the experience of stress-free living. However, we must focus on the damage that American conditioning has done to our mindset as a whole when it comes to relationships. Ladies, no man in America or in the world wants to be stressed out by his own woman. Men already face numerous obstacles and tribulations just living in America, especially BLACK men. To come home to stress after living a daily life of stress is equivalent to living in hell on earth.

Men, no woman in America wants to come home to being made to feel unwanted or unappreciated or as if she's not enough for you or good enough for you. When a woman does her very best to give you all that she has to give and you show behaviors of being unappreciative or distracted by other things outside of her efforts, this kills a woman's spirit. This eventually destroys her belief in the relationship. This also opens her up to receive the admirations and interests of a man who is truly ready for what she has to offer. Remember, men, just because your actions and the actions of other men may have damaged a woman's self-esteem and her inner drive to have what she wants and to be happy doesn't mean that she no longer possesses those amazing qualities.

All it takes is the right man to reactivate those jewels that are still a part of her. This is what happens when one man has a totally different experience with the woman you threw away. Just because you stopped moving her in a unique and loving way doesn't mean another man doesn't have the power to move her even more intensely in ways she never imagined. Men make this mistake all the time. We tend to think that no one else can impact a woman's mind, heart, and vaginal area the way we did. We think this way because we are physical creatures and always miss the biggest valuable point of all. A woman is stimulated by how you make her feel mentally and emotionally. The sex becomes out of this world because of all the other things you stimulate inside of her. It's not always the performance, unless that's all the relationship is about. A woman who is in love for all the right reasons will declare you being the best she's ever had because of the total experience of being with you. It is the way you treat her and handle her that adds to the bedroom. This is what another man could never compete with. Both sexes need to keep in mind that good sex comes a dime a dozen. But when you can stimulate the person's soul and make them see the depths of your personality, character, and spirit, that's what adds to the entire package.

A woman who doesn't stress her man gains the world. A peace of mind is a treasure for both men and women. Practice giving peace to each other and watch how both of you breeze through the storms.

Add spiritual guidance and humility, and nothing or no one can come between you.

The solution to all this is for both men and women to urgently get back to the old days of sincerity, wholesomeness, and loving a person because of all their inner qualities. Forget about what they do for a living. Stop holding on to these unrealistic standards that don't have anything to do with the inner beauty and quality of a person. If you meet someone who has the qualities that move you, then focus on those qualities and allow the connection to take its course. We tend to get in our own way of destiny by following traditions that never got us anywhere. Keep in mind that all traditions aren't good ones.

When you go after a man or woman for money or status, then that is all you get out of the relationship, and you never experience what love and happiness is really all about. If the money and status disappears, then you are left with a person you don't even love or barely even know. You fell in love with the status, image, or money, not the individual. Stop marrying for security. You can have security by connecting with a mate who is into you and you are into them. The two of you will keep each other in good standing and will refuse to see the other one fall or go without. And, ladies, let me tell you a secret about a man who truly loves you. I don't care if a man works for Burger King or a junkyard, if his heart and mind are rooted in you, he will do everything in his power and ability to give you the best that he can give you. And it is in that effort that makes him far better than any other man you could have chosen. These examples are not to promote you finding a mate that is mediocre. It is only to make the point that America has taught us that status, image, and money are what relationships are all about; and that is the biggest crap we could have ever bought into and is also partially the reason some of us continue practicing divorce. We don't identify with what real love and happiness are all about.

Conclusion

I like to conclude with solutions. I think providing a lot of information without offering ideas of solutions is a waste of time and a waste of the reader's time. We have been accustomed to waiting on people to lead us in this country. We have had some outstanding leaders in the past who laid down the foundation to help us arrive where we are today. I will always be grateful to all those noble men and women who sacrificed their lives to make sure another generation of lives would be better. However, today we don't necessarily need a leader to guide us because we are a more conscious people today. Among us are thousands of strong-minded leaders. Therefore, we must use the wisdom and gifts God gave us to lead ourselves out of oppression and destruction.

My solution is nothing magical or unheard of. It's simple and obtainable. The solution to all that we have endured as a negative impact of America is first eliminating ignorance on all levels. How do we eliminate ignorance? It is by refusing to allow people or any system to pour foreign ideas into your brain. Stop allowing other people to use your mind and get in the habit of using your own mind. Challenge things you are unsure of and dare to question what doesn't sound like truth. If you have yet to recognize truth, then simply read and study topics from UNBIASED sources. Articles written by people who are for one side will not deliver information that is balanced and truth. They will only disperse their views and how they want you to interpret the information they are providing. This is not true research.

Real research is an accumulation of information from unbiased sources that only give evidence-based findings—information

that may not feel good to read or hear but aligns with dates, history, and occurrences that add up to nothing but accuracy and truth. Be inquisitive; ask questions that you really want to know and leave hesitation and fear behind. Fear does nothing but keep you idle in one place, never growing or elevating. Don't be afraid to break tradition. All tradition isn't good. Just because it's been done for a hundred years doesn't mean it has benefited you or your community, nor does it mean that it is true. A lot of tradition is just repeating the same nonsense a lot of people before you repeated, and no one ever dared to challenge the information or seek beyond what was always taught to you. Dare to reach beyond what you are taught to believe. Find out what you don't know. Be one of the few who yearns for more knowledge when everyone else around you seems content being fed the same thing the past fifty years.

VOTE! Understand that if you plan to remain a citizen in the United States, then you must learn the system of America and why radical thoughts like not voting will never benefit you especially as black people. Conversations about third political parties is good, but only if discussed and organized years before an election. Talks of third parties are never realistic during an election period, so don't get caught up into it. It's another distraction by people who usually aren't going to do a damn thing but talk. Only if you see the numbers growing into the hundreds of thousands or millions establishing a third party should you take interest in it. Other than that, get away from those people talking about a third party. They are messing up the vote between the candidates that matter at that particular time.

No matter how much philosophy and theories you come up with, the system of America operates through voting in people to govern every community and concern. If you never show up to vote to have your concerns addressed, then those issues will continue for years unaddressed, especially if a large percentage of people continue to transfer that foolish mindset. Use basic common sense and your eyes God gave you and just observe the polls at voting time. If you see on the news and in person a lot of people of different races in line to vote, then you are a fool not to be in line with them. Throw away

the theories; they are designed to keep you blind and stupid, while progress is being made for those who are voting.

Be true to the cause that will help the people as a whole. This means any fight or push to grant the majority of people an opportunity to receive health care, job opportunities, and a better quality of life—join them. Recognize the difference between those who are promising this and those who are actually doing this. Look at the similarities of the people who are in leadership to your life. Analyze if they can relate to your livelihood and circumstances.

Don't allow your religious/spiritual beliefs control your emotions that blind your physical eyes and your cognitive ability to comprehend. Everyone carrying a Bible is not a godly person. Everyone who uses the biblical or religious terminology are not the chosen vessel of God. If you claim to be Christian, then study the Word for true understanding and stop allowing wolves in sheep's clothing to manipulate you all the time.

It has become beyond embarrassing to see Christians not be able to even tell that they are being misled by false profits and wolves disguised as sheep.

I have accomplished what I have accomplished because I can't be told just anything. No one can play on my emotions or my spiritual beliefs because I don't allow my spirituality to cloud my judgment. God gave me a mind, which is used as a tool, and you have to be an amazing scam artist to manipulate my mind. I don't look at everything spiritually, so that way, I can see things for what they really are, and then I know when to turn on my spiritual lenses to see things in a God-like manner. But what many of us miss as Christians is we have the spiritual lenses on ALL THE TIME, and this is why you can't see anything. So what happens is people see this in you and interpret it as a weakness, and they use the game to play to your spiritual lenses.

Many of you forget that God blessed us in spirit and in truth. However, you have to know the difference and when to use the natural gifts God gave us to see and recognize TRUTH, and be strong enough to accept the truth when you see and hear it.

Let your voices be heard. Stand up for what positively impacts mankind and denounce any behaviors or mindset that diminishes or harms any race or group of people.

Always be a part of the solution and never the problem. The problem can be discussed forever, but the solutions are all that matter and eliminates the purpose for discussion.

Don't waste time trying to change things that are not in your control. If you have no control over certain things, then you do yourself an injustice to spend time trying to change it. Trying to change something that is out of your control is like having passionate feelings about changing Stone Mountain into lake. There is nothing in the world that will give you the ability or magic to turn the largest rock in the world into a lake. So why waste your entire life on trying to change a rock that is so huge that it overlooks five states? Yes, maybe that's a little over the top of an example; however the point in trying to change people into something they fight against exemplifies the same extremity.

There are so many details and factors to every individual and so many reasons why people do what they do or end up the way they do. That is way too much to unravel especially by many of us who are not skilled or credentialed in areas of what we attempt to judge or speak on. The time should be spent focusing on those things that are in your ability to change and perfecting those things about ourselves. This type of mindset helps to make a better world because everyone is focused on improving themselves instead of trying to repair or change others.

Learn and practice the difference between choosing leaders who actually practice what they preach from those who pretend to be a part of what they practice. As a true Christian, you are supposed to be able to tell when someone is demonstrating false behaviors to appear to be a believer of your faith in order to get your vote. You are supposed to be able to discern those who are truly a believer of your faith. Being able to recognize these differences allows one to make quality decisions and impact the community in a positive and effective way.

Don't complain if you are not working to help the situation or toward the solution. If your only contribution is complaining or criticizing, then you become a part of the problem you're complaining about.

Practice diplomacy. Don't be fast to judge or escalate situations before exploring the possibility for conversation, negotiation, or a plan.

Don't make every situation a negative one. Speak positivity into a situation and hope for positive outcomes. Often when we chose to be negative and see everything in a negative way, it brings only negative outcomes. We can control situations and even the way people look at us or a situation we are facing together by presenting a positive outlook or approach. Take control of situations by demonstrating positive behaviors and attitudes.

Always allow your enemies to be your motivators to progress and elevate. Those who look for you to fail and have no sincere care for you or your endeavors should be your stepping stones to go even further. As a previous Atlanta radio personality, Porsche Foxx used to say, "Let your haters be your motivators."

Never stop remembering history and using it to inspire and motivate positive movement. Don't allow history to be changed or erased. Speak loudly on our history and how it positively impacts the minds of human beings today.

Change is good. Don't be afraid of change because it is through change that we evolve and elevate to higher levels of life and learning.

Destroy "Simon said" mentality! Study to show yourself approved. Love, embrace, and encourage "truth and positive change."

About the Author

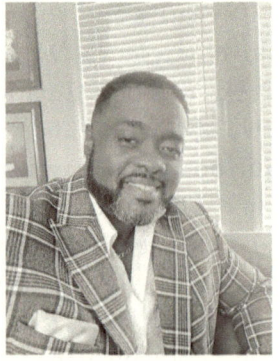

Danté Charles is an educator, mental health and substance abuse counsellor, education and business consultant, and entrepreneur who has taught and counseled children and adults in various areas of life. He is the owner of an assistant living and clinical housing organization that provides healing and clinical care to individuals with mental and physical disability. Danté has written numerous articles that address the social crisis of America and the ongoing epidemic of the black community. He has fought alongside state senators on laws to protect the lives of innocent black and brown people of America and contributed ideas to help govern the actions of those who are to protect and serve the public.

Danté Charles's passion is to eradicate ignorance and spread more wisdom and truth to elevate the black community, a nation of people, and the world. He believes that if people chase after knowledge with the same thirst they have for emotionally felt stories, then they will begin to live in the solutions to their life long problems.

www.ingramcontent.com/pod-product-compliance
Lightning Source LLC
Chambersburg PA
CBHW030759180526
45163CB00003B/1090